Watercolor Basics: Trees, Mountains and Rocks

ZOLTAN SZABO

NORTH LIGHT BOOKS
CINCINNATI, OHIO
www.nlbooks.com

ABOUT THE AUTHOR

Zoltan Szabo was born in Hungary, where he attended art school before immigrating to Canada in 1949, and then to the United States in 1980. An artist, author and teacher, his watercolor seminars have influenced thousands of artists in the United States, Canada, Europe and Saudi Arabia.

Szabo is the author of ten books, including *Zoltan Szabo Watercolor Techniques*, *Zoltan Szabo's 70 Favorite Watercolor Techniques* and *Zoltan Szabo's Color-by-Color Guide to Watercolor* from North Light Books. Szabo has served as an associate editor of *Decorative Artist's Workbook* magazine for five years and has been featured in publications such as *American Artist*, *The Artist's Magazine*, *Art West*, *Southwest Art* and *International Artist* and also in many books.

Szabo is an honorary lifetime member, founding board member and past president of many prestigious artistic societies. Thousands of his paintings are owned by private collectors throughout the world. His works appear in such noteworthy public collections as the Smithsonian Institution in Washington, D.C., and the Hungarian National Gallery Archives in Budapest, and in the collections of the prime ministers of Canada and Jamaica. Szabo has over thirty major solo exhibitions to his credit.

Watercolor Basics: Trees, Mountains and Rocks. Copyright © 2000 by Zoltan Szabo. Manufactured in China. All rights reserved. No part of this book may be reproduced in any form or by any electronic or mechanical means including information storage and retrieval systems without permission in writing from the publisher, except by a reviewer, who may quote brief passages in a review. Published by North Light Books, an imprint of F&W Publications, Inc., 1507 Dana Avenue, Cincinnati, Ohio 45207. (800) 289-0963. First edition.

Other fine North Light Books are available from your local bookstore, art supply store or direct from the publisher.

04 03 02 01 00 5 4 3 2 1

Library of Congress Cataloging-in-Publication Data

Szabo, Zoltan.
 Watercolor basics: trees, mountains and rocks / by Zoltan Szabo.—1st ed.
 p. cm.
 Includes index.
 ISBN 0-89134-975-8 (paperback)
 1. Trees in art. 2. Mountains in art. 3. Rocks in art.
 4. Watercolor painting—Technique. I. Title: Trees, mountains and rocks. II. Title.
ND2244.S98 2000
751.42'243—dc21

 99-055745
 CIP

Edited by Joyce Dolan
Production edited by Stefanie Laufersweiler
Production coordinated by Sara Dumford
Cover designed by Wendy Dunning

ACKNOWLEDGMENTS

Authors know very well how many skilled and hardworking professionals it takes to publish a book of this caliber. We enjoy the limelight, but in my case I want to share it with my helpers because their hard work and encouragement were essential ingredients for the birth of this work.

To Willa McNeill, my faithful helper and morale booster; to Rachel Wolf, acquisition editor, who first approached me with the idea; to Joyce Dolan, my wonderful and patient editor; and to Stefanie Laufersweiler, my production editor, I offer my gratitude and thanks for their invaluable contribution.

DEDICATION

Most of the readers of this book probably consider themselves beginners. Because of the temperamental character of our beloved medium, watercolor, we are all beginners at different levels. It takes courage to take on this unknown fickle companion. I dedicate this book to you, the reader, who is brave enough to start and, hopefully, stubborn enough to continue and enjoy the rewards of creating beauty.

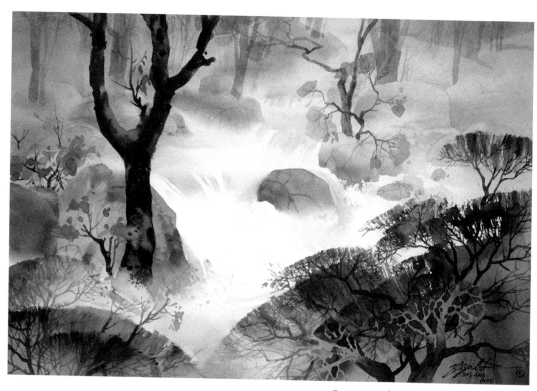

Steam Bath
15"×22" (38cm×56cm)

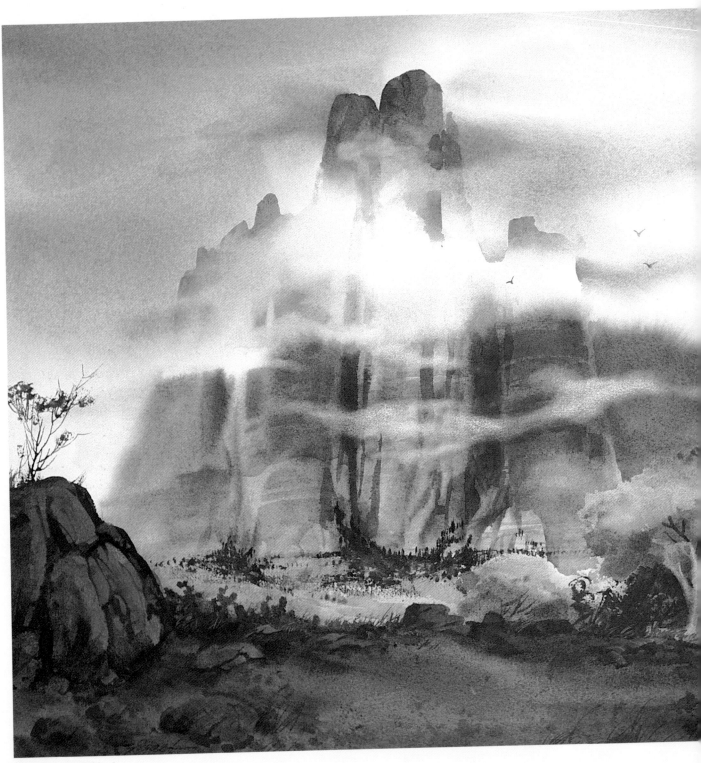

Head in the Clouds
22″×30″ (56cm×76cm)

CONTENTS

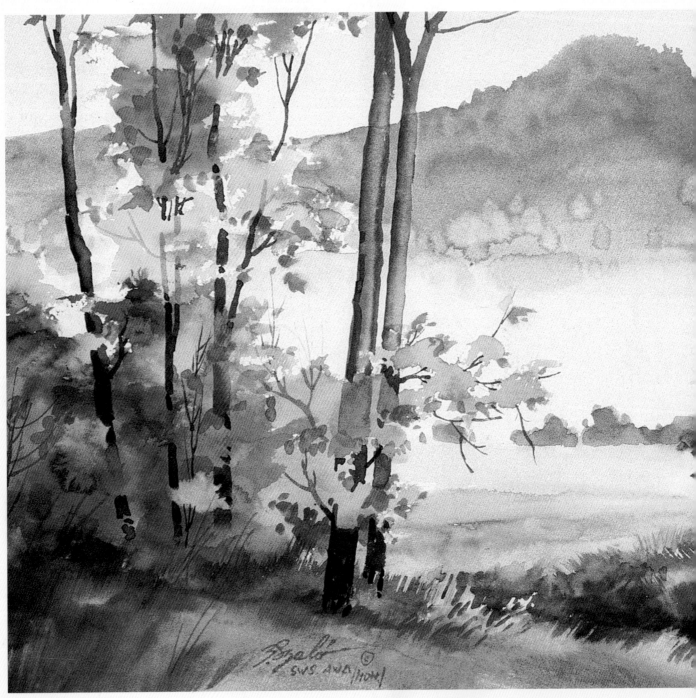

Autumn Maples
11" × 15" (28cm × 38cm)

INTRODUCTION

My purpose in this book is to expose you to a variety of techniques and moods while using individual subjects presented in all kinds of conditions. I want to avoid pigeonholing subjects in narrow selections of techniques, because there are so many ways to portray things with paint. When we paint recognizable subjects, they should resemble the real thing. Painting them in watercolor should also show off the beauty and the endless variations of watercolor techniques.

Winslow Homer, Andrew Wyeth and Ted Kautzky have painted images that we recognize with ease. At the same time, their paintings represent a personal approach to watercolor which evolved from each artist's individual philosophy of life. I intend to guide you in increasing your knowledge of nature, while still encouraging you to paint watercolor your way.

Trees, mountains and rocks cover a huge portion of the natural landscape. They add majesty and solidity to our world. Trees supply us with life-giving oxygen and give us cool shade and comfort while enhancing our lives with their beauty. Mountains are a challenge for humans. We want to climb them, carve them or just enjoy looking at them. Rocks are the crust of our Earth. We admire their strength, mine them and even make beautiful statues out of them. Remember that Michelangelo's *David* began as a piece of rock. Enjoy this tour of nature with me, and don't ever stop learning.

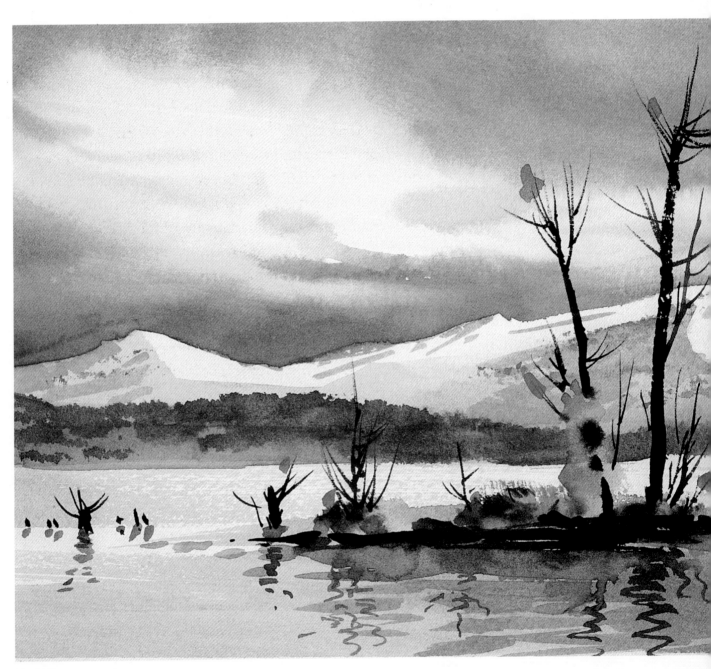

Early Snow
15″×22″ (38cm×56cm)

GETTING STARTED

Tools are as important to a watercolorist as to a doctor or a carpenter or any professional. You could buy all the tools that artists swear by, but you'd better be a Rockefeller to do so. After a few years of experimenting, each of us chooses our own favorite tools, which become old reliable friends. I'm no exception. I have my favorites that work well, and I can honestly recommend them. I've used the supplies on the following pages for all the work in this book. If you'd like to try them, you should be able to find them at your neighborhood art dealer. If not, we'll gladly help you out through the mail. Contact us at Zoltan Szabo Workshops, 336 Forest Trail Drive, Matthews, North Carolina 28105-6595.

Tools

Brushes

The brushes I habitually use are:

- 1½-inch (4cm) and 2-inch (5cm) soft, flat slanted synthetic brushes
- 1-inch (2.5cm), 1½-inch (4cm), 2-inch (5cm) and 3-inch (7.5cm) flat slanted bristle brushes
- no. 10 and no. 12 Richeson Series 9000 synthetic round brushes
- no. 5 rigger
- ¾-inch (2cm) and 1-inch (2.5cm) flat aquarelle brushes
- a wide, flat natural bristle brush (to wet the paper)

Paper

My favorite papers are major-brand, 300-lb. (638gsm) cold-pressed pure rag watercolor papers like Arches, Lanaquarelle and Kilimanjaro.

I use the 300-lb. (638gsm) weights strictly for convenience; heavy papers don't buckle when wet like the thin ones do. Heavy papers soak up more paint than the thin papers, so you must compensate for the loss of color by painting a little richer.

Paint

For the sake of consistency, I used MaimeriBlu artist-quality transparent watercolor paint throughout this book. I squeeze these colors onto my palette in advance and allow them to dry for economy. MaimeriBlu colors do not crack when dry, and they dissolve instantly with just a gentle touch of a wet brush.

Miscellaneous

- no. 5 palette knife
- a natural sponge
- two plastic containers for water
- facial tissues
- toilet paper
- paper towels

Tip

Brushes usually absorb too much water when dipped into a bucket. You can make a handy moisture-controlling contraption from a roll of toilet paper. Take out the center core of the toilet paper and flatten the roll. Then wrap a few sheets of lint-free paper towel around the outside of the flattened toilet paper. Fold the paper towel to the same width as the toilet paper roll and tape the edge to stop it from unrolling.

The toilet paper is very absorbent but it breaks down quickly when moistened, releasing tiny particles that can be carried onto the painting. The paper towel around the roll prevents this from happening. Make a habit of touching your brush to the surface of the paper roll before you dip into a color. Controlling moisture in your washes begins by controlling it in the brush.

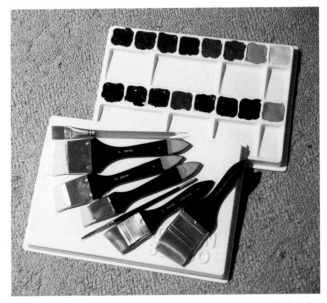

The photo shows my palette with dry colors; 1-inch (2.5cm), 1½-inch (4cm) and 2-inch (5cm) slant bristle brushes; 1½-inch (4cm) and 2-inch (5cm) soft slant brushes; a ¾-inch (2cm) flat aquarelle brush with transparent plastic handle; and a no. 5 rigger. The palette and the slant brushes are my own design.

Techniques

This section includes only the most important and truly different watercolor techniques. An attempt to describe all the complex properties of our chosen medium would take a larger book.

Wet-on-Dry

This is the most conventional approach to watercolor. You work on dry paper with a brush well-loaded with water and paint.

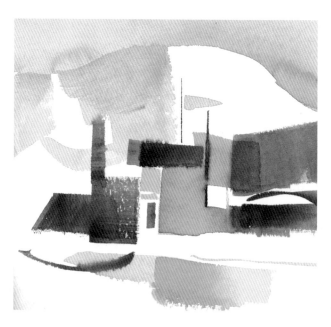

Tip

Some high-quality papers have starch on the surface that causes wet brushstrokes to bead. To prevent this, gently wipe the starch off with a wet, soft brush or sponge. If you don't saturate the paper it will dry quickly; you can speed up the drying time with a hair dryer.

Wash

A wash is the application of wet watercolor to an area. The paper may be dry or wet, but the applied wet color is still called a wash.

EXAMPLE 1
In this study completed with the wet-on-dry technique—wet paint on dry paper—the values of the brushstrokes are the dominant feature. The more paint in the brush, the stronger the color.

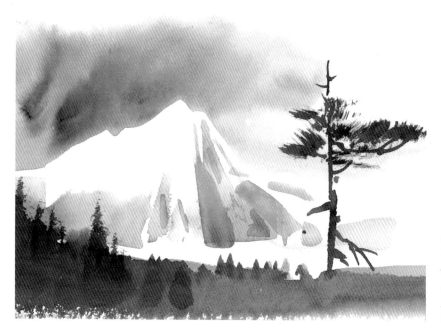

EXAMPLE 2
Here I painted around the white to make the mountain shapes. Notice the sharp edges; the wet brushstrokes had to be applied onto a dry surface or they would have blurred.

Wet-into-Wet

The most important requirement for this water-color technique is thoroughly saturated paper. The heavier the paper the longer it will stay wet. As you apply washes over the wet paper, the value of the color lightens a little because more pigment disappears into the wet paper than it would on a dry surface. While the paper is shiny wet, the brushstrokes will blend blurry. If you use less and less water as the paper dries, the edges will appear sharper, though still a little soft.

After the shine is gone but the paper is still damp, even a little water in your wash may cause a backrun. This is a wet shape that spreads out of control and dries as a blob with a hard edge. I think the wet-into-wet technique is the most fun during the short period between very wet and very dry conditions.

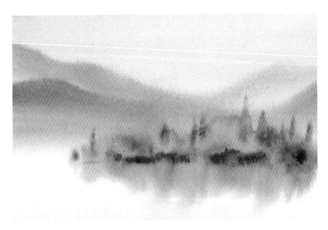

EXAMPLE 1
For this study I used a 1-inch (2.5cm) slant bristle brush on a saturated, shiny-wet surface. I started with the gray hills and dropped in the strong yellows with much water and paint, encouraging the color to spread. For the darker browns and greens I used mostly paint and hardly any water.

EXAMPLE 2
This illustration was painted with very thick paint in the brush while the paper was submerged in shallow water. This way the paper couldn't start drying until I finished.

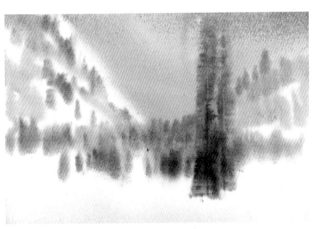

EXAMPLE 3
Here I mixed Burnt Sienna and Ultramarine Deep together using a 1-inch (2.5cm) slant bristle brush on a very wet surface. Where the two colors were applied equally they separated, such as in the background. I varied the dominance of one of the colors in places such as the tall foreground trees.

Backruns

A backrun is a wet shape that spreads out of control and dries as a blob with a hard edge. It occurs when an already applied color is drying and some extra water touches the wash. When this happens accidentally, you can try to incorporate it into the design, try to repair it after it dries, or abandon ship. I think of the backrun as an expansion of the wet technique and use it to excite my painting.

Drybrush

The name of this technique says it all. Your paper is dry, and the paint in your brush is barely moist. For best results, use cold-pressed medium-rough or rough paper. A gently held, dry brush will deposit color only on the top of the bumps on the paper. The pockets stay unpainted, and a sparkling textured effect is the end product. This is a great way to indicate rough textures like rust, algae or tree bark.

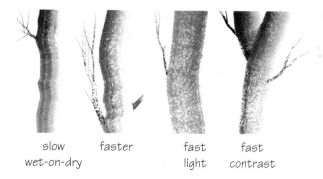

slow wet-on-dry faster fast light fast contrast

VARIATIONS
Here are some examples of dry-brush variations. For the trunk labeled "fast light" I used a lot of water in the paint and moved the brush fast. For the trunk labeled "fast contrast" I used richer paint, but still moved the brush fast.

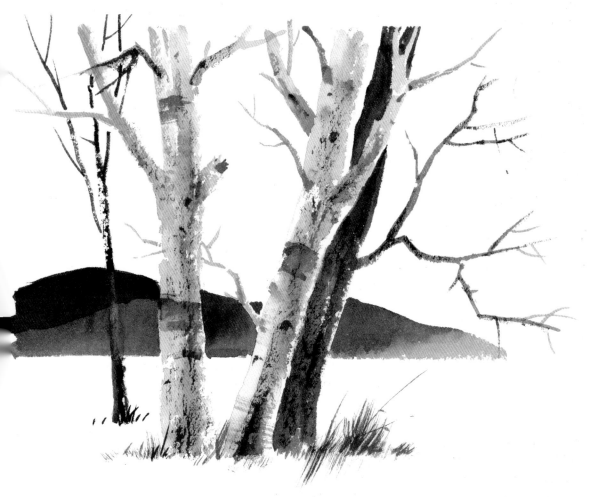

EXAMPLE
I painted the rough texture on the trees and grass with a dry round brush dragged on its side fast enough to touch only the peaks of the paper. I also used very dark color.

Glazing

This technique refers to wet washes applied on top of a dry color without disturbing it. The transparent nature of watercolor makes these overlapping colors behave and look like colored glass superimposed on another colored glass. The overlapping colors combine and become a new color that is stronger in value than either original color alone. Glazing may be applied several times, but allow each layer to dry before applying the next.

For best results use only the truly transparent colors, particularly if dark shades or intense colors are needed. A few of these colors are Phthalo Red, Quinacridone Red and Quinacridone Orange, Alizarin Crimson, Hooker's Green, Phthalo Green, Sap Green, Antwerp Blue, Phthalo Blue and Prussian Blue. Be aware that there will be some variation between brands.

Opaque and earth colors are fine for the base wash if well diluted. Use these carefully because they build up into a muddy opaque layer when glazed in heavy consistency. (I recommend that you avoid these colors for glazing.) Some examples are Cadmium Red, Cobalt Green, Olive Green, Viridian, Winsor Emerald, Cadmium Yellow, Yellow Ochre, Burnt Sienna, Raw Sienna, Burnt Umber, Raw Umber and Cobalt Blue.

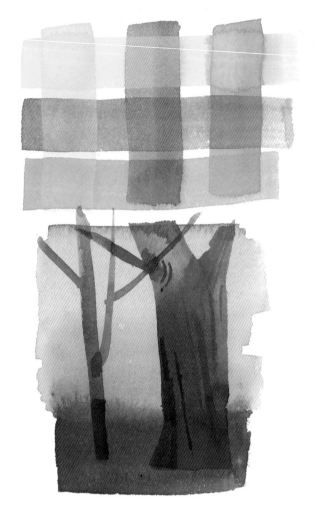

DARK GLAZES
This small study shows a warm-dominated color combination with dark glazes over light and medium values. I used the three primary colors.

Tip
When a brushstroke of rich color is painted across a waterproof black line and the color disappears completely over the black, the color is transparent.

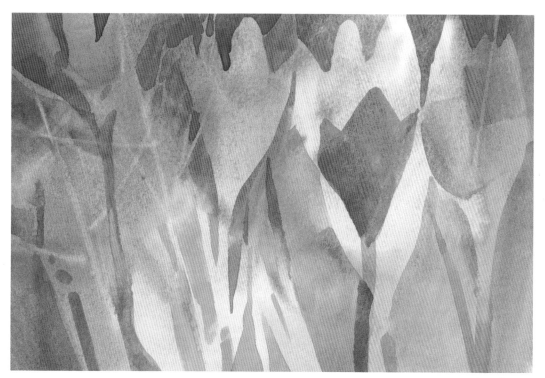

GLAZE
VARIATIONS
I started this illustration with an abstract wet-into-wet background. The final negative and positive tulip shapes came after the first wash was bone dry. The gentle variations in the glazes respond to design needs of the base wash.

Definitions

Analogous colors—those hues located next to or very close to each other on the color wheel.

Complementary colors—two colors located directly opposite each other on the color wheel.

Negative painting—painting the dark area around a lighter object to reveal the object's form.

MEDIUM GLAZES
The glazed shapes are medium value over a light or medium base. The cool colors are analogous, and the red is almost complementary.

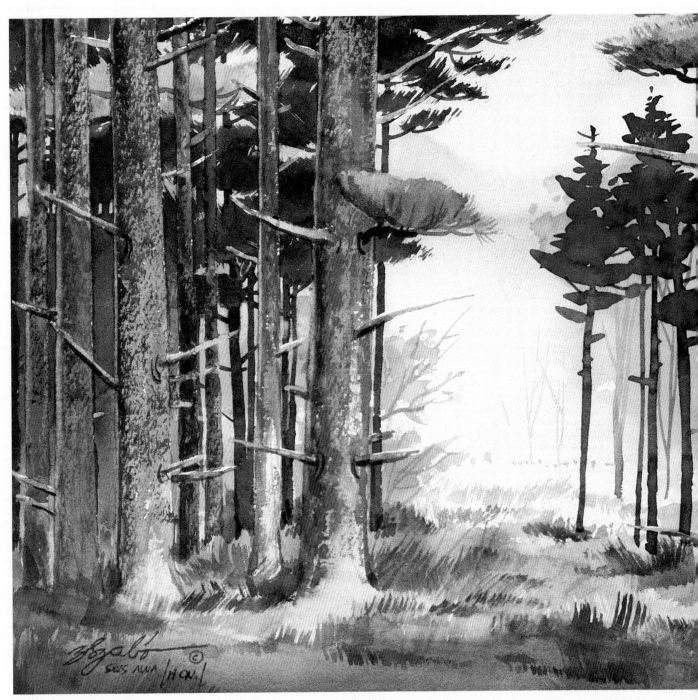

Forest's Edge
11″×15″ (28cm×38cm)

TREES

Trees supply us with vital oxygen as well as majestic beauty. Besides their abundant practical qualities, their aesthetic appeal is universal. Each species has unique characteristics, so an artist needs to know what trees look like and their basic nature. Their environment also needs to be correctly represented in a painting. The key to this is knowledge. In this chapter you'll become familiar with a variety of trees. No book, however, is as good a reference as nature. Study trees wherever you are; endlessly sketch and photograph them. Observation of the real thing is the greatest source of knowledge.

Deciduous Trees

This tree group is the largest provider of life-giving oxygen. They cover the land with wonderful foliage. Their color is fresh—yellow-green in the spring, deep green during summer, brightly colored yellow-orange or red in the fall—and their leaves fall off in the winter. Their foliage grows in clumps on the branches and looks like umbrellas. These clumps have light tops and dark interiors. They vary in shape and size and loosely assemble to create the crown of the tree. The branches are the thickest at the trunk and thinnest at the tip. Deciduous trees are the best shade trees, and they supply artists with wonderful moods.

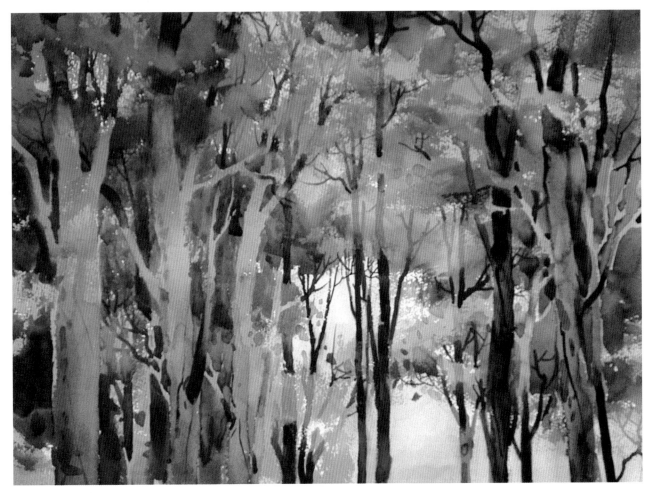

Green Umbrella
15″ × 20″ (38cm × 51cm)

Elm

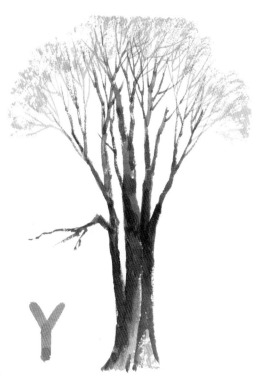

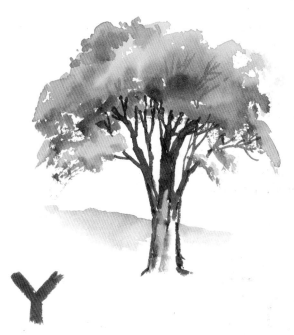

ELM IN SPRING
The characteristic Y shape in spring is somewhat open because the buds are becoming fuller and heavier at this time. Their weight starts to spread the branches.

ELM IN SUMMER
The leaves are full of moisture in the summer. They are at their heaviest and spread the branches to the maximum. The Y is fully open.

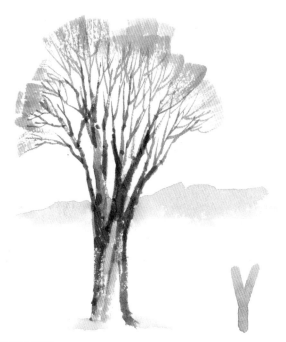

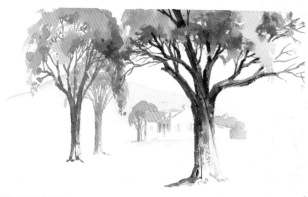

ELM IN AUTUMN
Elms remain wide in autumn, almost like in summer. The leaves are still damp and are dominated by yellows and their shaded, warm analogous colors—oranges and siennas.

ELM IN WINTER
The branches tighten their Y in winter because the leaves are gone and nothing weighs them down.

Oak

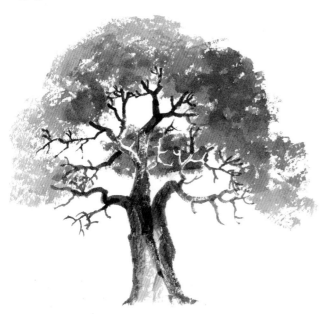

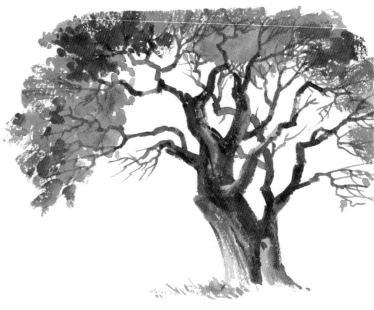

OAK IN SUMMER
Oaks spread their rugged branches wide. The summer foliage is full and the weight of the leaves is well supported by the powerful limbs.

OAK IN AUTUMN
Oak leaves turn reddish brown in late autumn and drop slowly, clinging to the branches even during winter. The dry leaves supply welcome warm color amid the cool color that dominates the winter landscape.

OAK BRANCHES
Oak branches stick straight out of the limbs at a right angle and then bend up or down over and over.

OAK LEAVES
The shapes of the leaves and acorns vary slightly from species to species, but, in general, they resemble this illustration.

DYING OAK LEAVES
Oak leaves take a long time to deteriorate. They lose color after they fall off the tree, but they retain their shape for quite awhile.

Willow

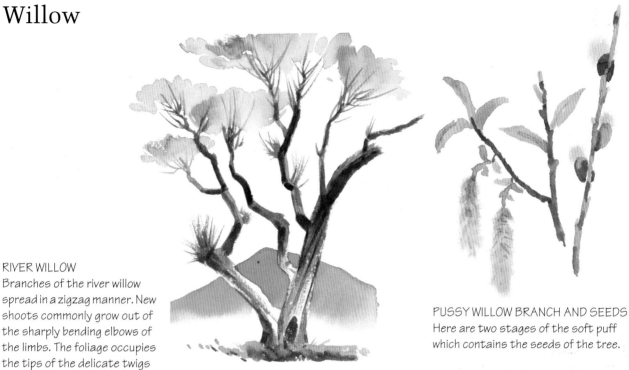

RIVER WILLOW
Branches of the river willow spread in a zigzag manner. New shoots commonly grow out of the sharply bending elbows of the limbs. The foliage occupies the tips of the delicate twigs in clusters.

PUSSY WILLOW BRANCH AND SEEDS
Here are two stages of the soft puff which contains the seeds of the tree.

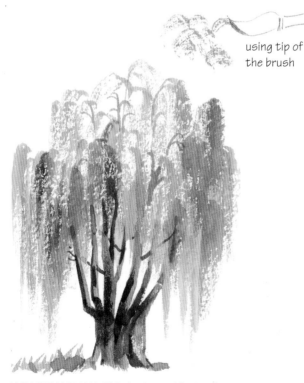

using tip of the brush

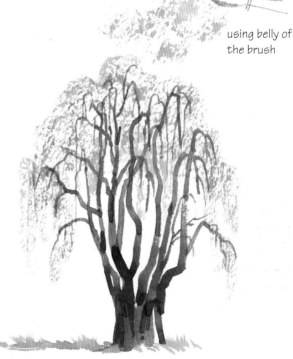

using belly of the brush

USE DRYBRUSH FOR A WEEPING WILLOW
Weeping willows form their leaves on long, very thin branches that bend and hang straight down from their own weight. The dry-brush technique is ideal for painting the drooping character of this tree. The tip of the brush and the hair next to it do the best job.

WEEPING WILLOW IN SPRING
Young leaves on the tree have a lacy texture. The structure of the branches is clearly visible when the willow is in this condition. To achieve this texture using drybrush, hold the brush sideways and use the belly. Do not touch the paper with the point of the brush.

Maple

MAPLE IN SUMMER
The foliage on a maple grows in an egg shape. While the tree's outer edge tends to be symmetrical, its interior has foliage divisions where the sky breaks through, making the tree fun to paint.

MAPLE IN AUTUMN
Maples drop their leaves starting from the top. The foliage on the bottom hangs on longer. This adds further excitement to their autumn show.

MAPLE LEAF
A maple leaf is defined by five points. The leaves are green in the summer but turn brilliant yellow, orange, red and maroon in the fall. They form the most colorful autumn display of any tree.

BRILLIANT COLOR
Fall leaves on young maples are so colorful you can use all Cadmium Yellows, Cadmium Oranges and Cadmium Reds to achieve their brilliance.

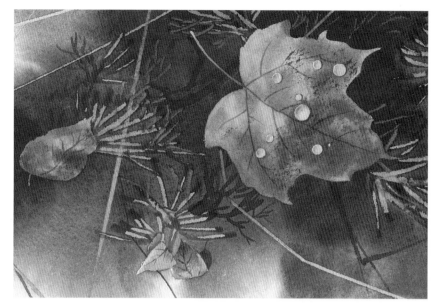

PAINTING A FALLEN MAPLE LEAF
A fallen maple leaf with a few beading water droplets became the subject of this watercolor. First, I masked out the leaf and painted the dark green background. While this wash was wet I scraped out the light green weeds with the slanted tip of my plastic brush handle. Next I removed the masking and painted the large leaf using Burnt Sienna, Raw Sienna and a little violet. After drying, I scrubbed out the shapes of the water drops and shaded the leaf for a three-dimensional look.

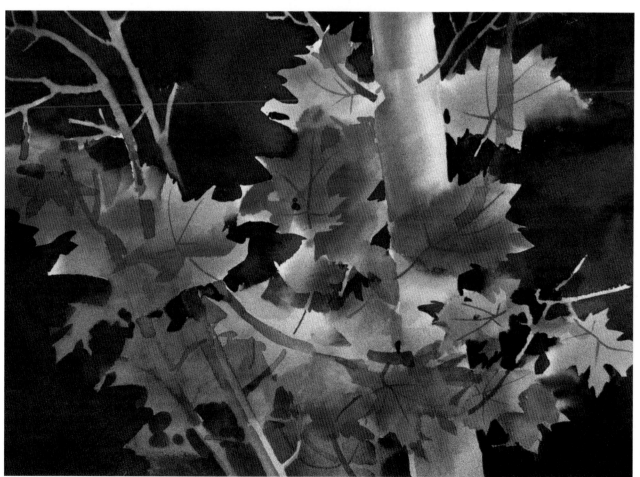

COLORFUL LEAVES
I painted this colorful cluster of fall maple leaves the same way as in the previous example. I masked out the leaves and branches and finished the dark background first, then removed the masking and painted the leaves and branches.

Step by Step: *Autumn Maples*

COLORS

Cadmium Yellow Lemon | Burnt Sienna | Primary Red Magenta | Permanent Violet Bluish | Cupric Green Deep

Step 1
Start on a dry surface with a very wet ¾-inch (2cm) aquarelle brush randomly loaded with all five colors in strongly varied dominance. The brushstrokes need to ooze and blend as they touch. Some of the protruding edges will resemble maple leaves. Blend colors so that yellow and red are dominant.

Step 2
Add depth to the foreground and establish the darker base shape for the middle ground, leaving out a negative edge for the grassy foreground. This is important to redirect that edge away from the distracting corner.

Step 3

Gently wet the background with clean water and paint the pale gray for the sky with a 2-inch (5cm) soft slant brush using Permanent Violet Bluish, Cupric Green Deep and a touch of Burnt Sienna. As the paper dries, apply the distant mountain—darker at the top and lighter at the bottom—using the same three colors with violet dominant. While the wash is wet, charge Primary Red Magenta spots into it for color variation. As the wash becomes more dry, create a few backruns with a mix of orangy water droplets. Paint the grassy meadow with Cadmium Yellow Lemon, Burnt Sienna and Cupric Green Deep. Wet-lift a few vertical shapes from the violet background after it dries to regain the white paper for future tree trunks.

Step 4

Paint the larger tree trunks with your aquarelle brush using Cupric Green Deep, Permanent Violet Bluish and Burnt Sienna, and then add a few small charges of Cadmium Yellow Lemon and Primary Red Magenta. Apply the smaller limbs and branches with a rigger and a dark combination of the same three basic colors. Show the shapes of the dark trunks behind the foliage with a dark overlap of the foliage color. This will add a luminous glow and delicacy to the foliage and strength to the structure of the trees.

Autumn Maples
11" × 15" (28cm × 38cm)

Charging
Alter the hue in a section of a very wet wash by brushing another wet color into it.

Birch

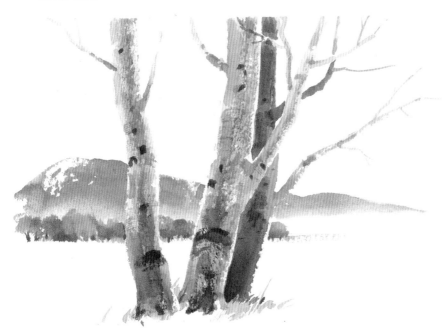

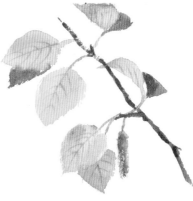

BIRCH LEAVES
The leaves, shaped like a spade, are pointed. They change color from green in the summer to bright yellow in the fall. The seeds grow in fluffy clusters.

TEXTURED BARK
When birch trees are backlit they don't appear white because they shade themselves. The most important identifying feature of all birch trees is the texture on the bark. To achieve this texture, first paint the basic color and tone value with runny paint. After this dries, paint the texture with several layers of glazed dry-brush strokes.

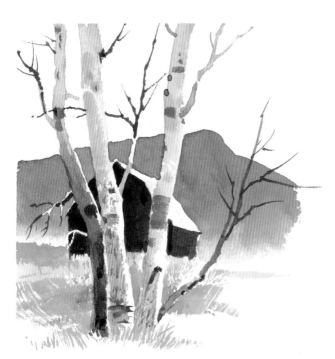

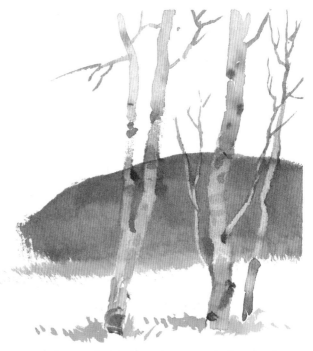

LIGHT BIRCHES
Against a dark background the bark of a birch looks very light in color except in shaded areas. A slight exaggeration in value usually increases the drama of the composition. ·

Where the shapes of a birch trunk cross a dark and wet background, you can scrape off the light shape by pressing with a firm but smooth instrument. The slanted, smooth end of a plastic brush handle works well.

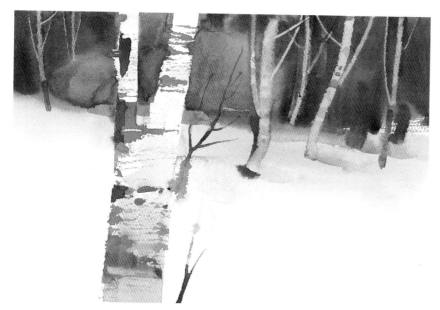

USE PALETTE KNIFE FOR DRY-BRUSH EFFECT

Achieve the dry-brush texture on a large birch trunk like this by rapidly dragging the edge of a palette knife filled with color. For the light trees against the dark background I squeezed off the wet color with the tip of my brush handle.

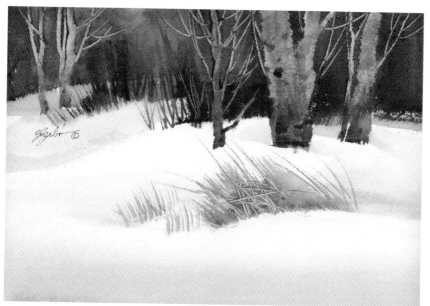

WINTER SCENE

This simple winter scene shows the scraped-out trees in an actual composition. The color and texture are exactly the way the scraping left them without any touch-up.

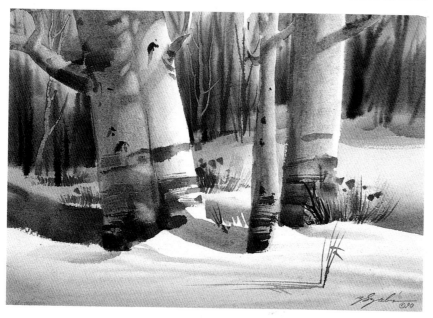

PROTECT WITH MASKING TAPE

The power of these somewhat stylized birch trees created a good center of interest. I protected the edges of the light tree trunks with masking tape while I painted the background sections with the wet-into-wet technique. For the details and the items on the snow I used a conventional glazing approach.

Step by Step: *Snowy Birches*

COLORS

Permanent Green Yellowish | Cupric Green Deep | Cobalt Blue Light | Permanent Violet Bluish | Burnt Sienna

Step 1

Start on dry paper. With your ¾-inch (2cm) aquarelle brush paint the shapes of the tree trunks with two grays charged into one wash. Use Cobalt Blue Light and Burnt Sienna as well as Permanent Violet Bluish and Cupric Green Deep accented with a little Permanent Green Yellowish. After this dries, drop in the dark marks left by the broken-off branches. Next, drybrush the base color for the bark on the largest trunk with Permanent Violet Bluish, Burnt Sienna and Cupric Green Deep. Use the flat belly of your aquarelle brush and hardly any water.

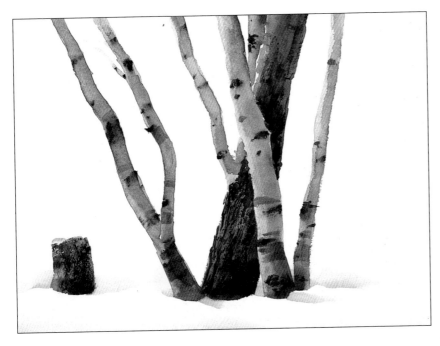

Step 2

Next paint the randomly spaced horizontal Burnt Sienna bands around the larger trunks. Add a stump for balance. Finish the texture on the rough bark in the same dark color with more drybrush strokes.

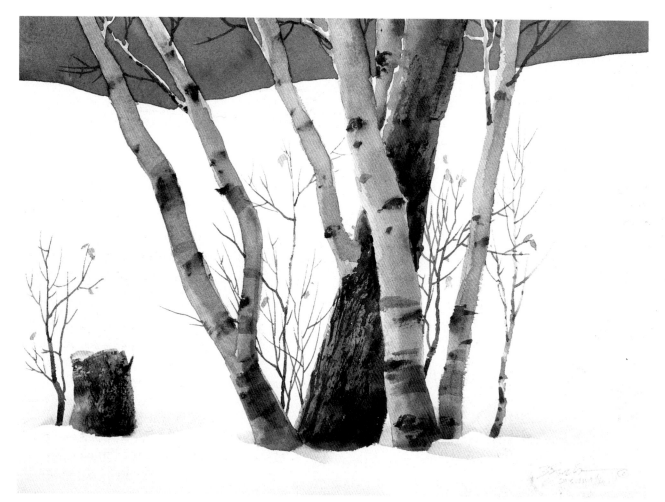

Steps 3 and 4

The dark blue sky defines the top edge of the
snow-covered hill. Apply a mixed wash of
Cupric Green Deep and Permanent Violet
Bluish wet-charged with a little Burnt Sienna
between the limbs as little islands of wet color.
Leave out a few small white branches (negative
painting).

Using your aquarelle brush, paint the dimples
into the snow next to the trees and the shading
at the bottom edge. Carefully design the brush-
strokes on the bottom edges to define the white
tops of the snow mounds. Blend away the top
edges with a thirsty damp 1-inch (2.5cm) slant
bristle brush. Apply the calligraphic young shoots
with a small rigger using the same colors as for
the larger limbs. Finish the sketch with a few dry
leaves in Permanent Green Yellowish and Burnt
Sienna.

Snowy Birches
11″×15″
(28cm×38cm)

Dogwood

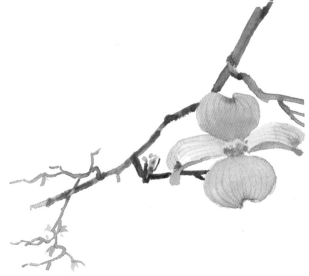

DOGWOOD IN SPRING

Dogwood trees show off a large load of blossoms in the spring. The dogwood is a southern tree, but grows as far north as Massachusetts. White, shown here, is the most common blossom color. They grow in heavy clusters creating exciting negative patterns. The branches hold up the flowers like upturned claws.

DOGWOOD FLOWER

A single flower shows a burn mark at the end of each of four petals. Notice the slightly darker veins in the petals.

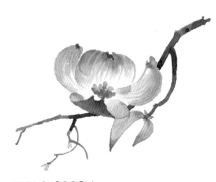

PINK BLOSSOM

The pink blossom has the same burn marks and veins as the white flowers but in a rich pink color. The new leaves have a slight reddish point that turns green later.

PINK DOGWOOD

Pink dogwood blossoms are not as common as the white blossoms. Their beauty adds color to the countryside after the modest colors of winter. The structure of the tree is identical to the white dogwood.

Step by Step: *Spring's Here*

Permanent Yellow Deep

Primary Red Magenta

Permanent Violet Bluish

Cobalt Blue Light

Cupric Green Deep

Step 1
For this effect use thoroughly saturated paper. Use a 1½-inch (4cm) soft slant brush and splash on all five colors in medium strength but in visibly different dominance. These washes will establish a pleasant but very soft background for the flower shapes to come.

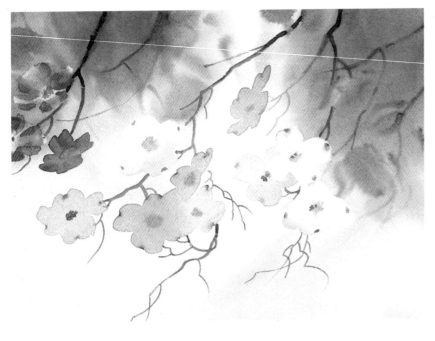

Step 2

Although the paper is still damp, switch to a ¾-inch (2cm) aquarelle brush because it naturally holds less water than the bigger brushes. Start the pink blossoms using Primary Red Magenta, Permanent Yellow Deep and a touch of Cobalt Blue Light. For the silhouette of the white blossoms, apply a single pale wash of Cupric Green Deep, Permanent Violet Bluish and a touch of Cobalt Blue Light, and a few spots of Permanent Yellow Deep for the flower centers. While the background is damp, wipe off the color to expose the shapes of the white flowers. Use a thoroughly cleaned brush squeezed damp dry so it can lift off the damp color without adding water.

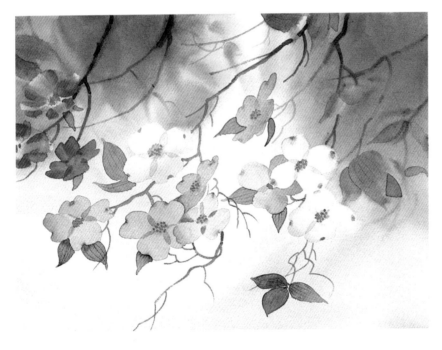

Step 3

When the paper is dry, establish the branches with a rigger and the complementary green leaves. Scratch dark lines into each of the freshly applied wet shapes with the pointed tip of a small brush handle to show the veins of the leaves.

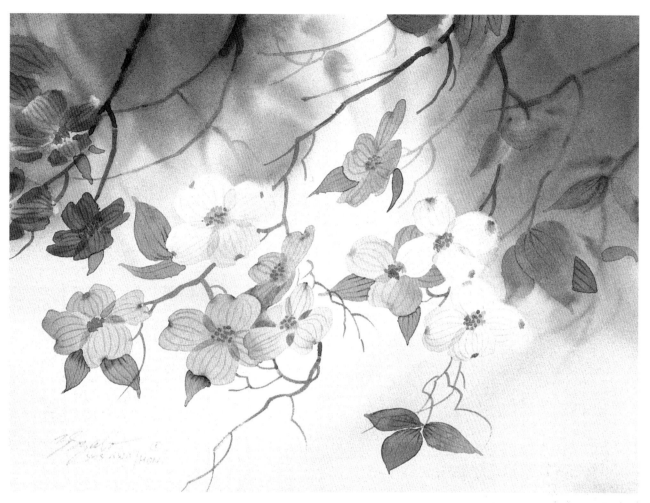

Step 4

Darken some of the details on the blossoms and
improve the definition on their yellow centers
as necessary. With a small rigger, paint the line
pattern into each petal using their local color in
a little darker value.

Spring's Here
11" × 15" (28cm × 38cm)

Sycamore

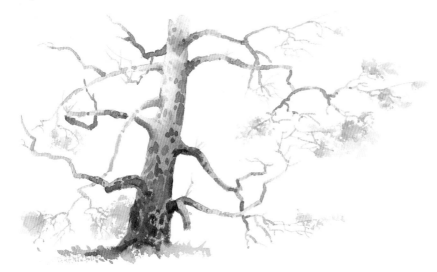

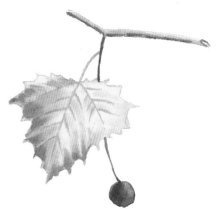

SYCAMORE LEAF
The sycamore leaf resembles that of the maple, but is much larger.

SYCAMORE
The sycamore is most easily recognized by its impressive size and the dark leopard-like spots on its light bark. The branches protrude at a ninety-degree angle around the trunk and curve wildly in every direction.

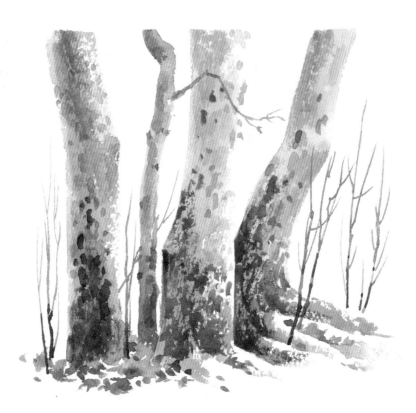

BASE OF THE SYCAMORE
The sycamore trunk is darker at the base and lightens as it ascends. The dark leopard-like spots break up the dark color. Young shoots grow all around the base.

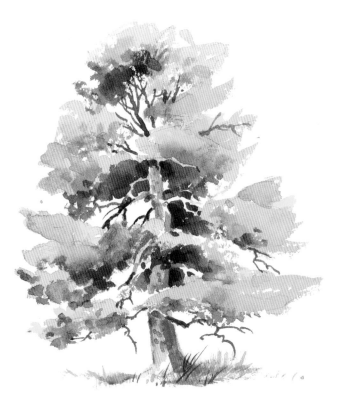

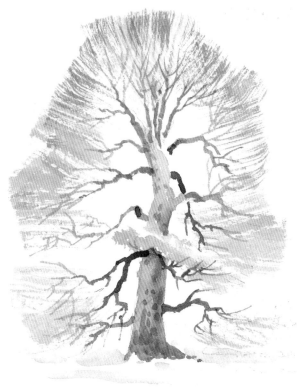

SYCAMORE IN FALL
Sycamores turn a golden yellow in the fall.

SYCAMORE IN WINTER
The structural anatomy, which includes thousands of fine twigs, is exposed in the winter. Use the dry-brush technique to paint the sycamore in winter. Start at the tip of the branches, move your brush rapidly and gradually lift it toward the interior.

Evergreens

The word "evergreen" is self-explanatory. The color of the foliage on these beautiful coniferous trees doesn't change. They have needles rather than flat leaves like their deciduous cousins. The size of adult evergreens varies tremendously from a dwarf-size alpine fir to a giant sequoia. Some evergreens grow in tough environments like very high mountains, while others enjoy a semitropical climate. They're as hardy as they are beautiful. The longest-living trees on Earth are evergreens, truly nature's wonders.

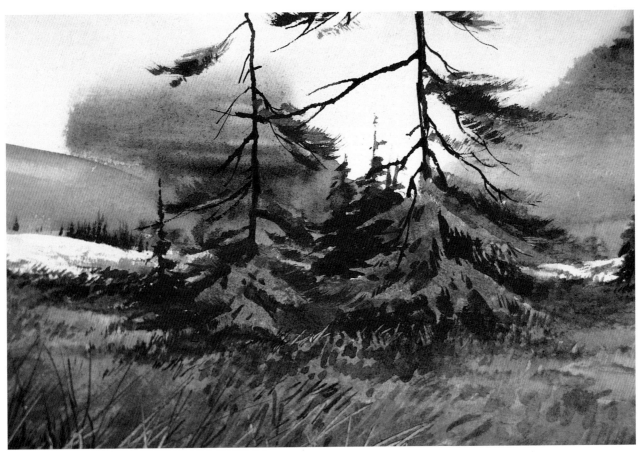

Alpine Fir
11" × 15" (28cm × 38cm)

Pine

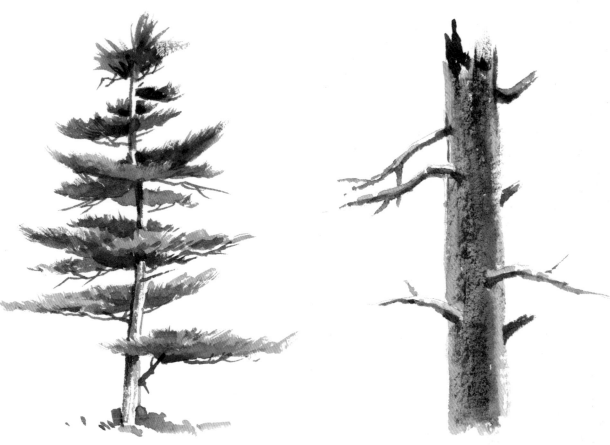

EASTERN WHITE PINE
There are dozens of pine species, but the eastern white pine is one of the most common. The foliage clusters are composed of long needles and point upward.

PINE BRANCHES
Pine branches start upright from the trunk and form an elbow as they turn downward carrying the heavy load of needles.

BARK ON OLD PINES
The bark on older pine trees is coarse. To paint it, use a dark brown base color in a tacky consistency and knife out the light spots with the heel of your palette knife.

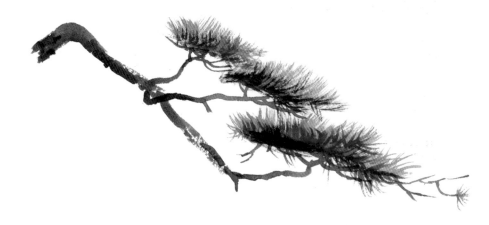

BRANCH WITH FOLIAGE
Notice how the thin, expanding twigs of the branches hold up the foliage like a waiter's fingers hold up a tray.

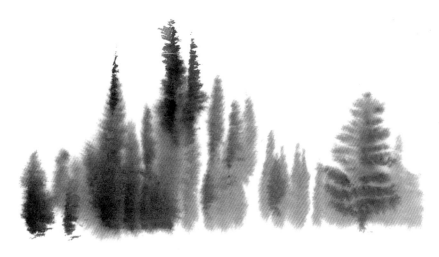

PAINT A CLUSTER OF DISTANT EVERGREENS

Use moist paper with a firm bristle brush (I used a 2-inch [5cm] slant bristle brush). Your brush must have rich paint and very little water to control the blurry edges. Hold the brush vertically, touch down and repeat. For the tree on the right I held the brush horizontally. Add the sharp points to the tops of the trees after the paper dries.

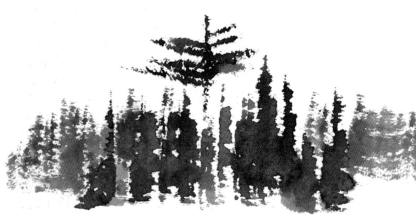

PAINT ON DRY PAPER

The same technique is used here but looks like this when painted on dry paper.

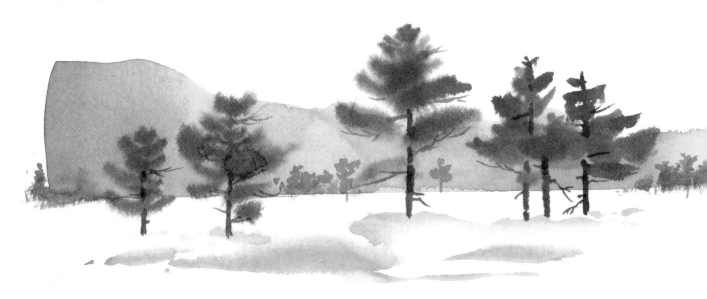

MIDDLE-GROUND PINE TREES

A similar technique, but with more randomly repeated brushstrokes, creates middle-ground pines. Add the trunks and branches after the paint dries.

Step by Step: *Misty Valley*

COLORS

Raw Sienna Burnt Sienna Ultramarine Deep Cupric Green Deep

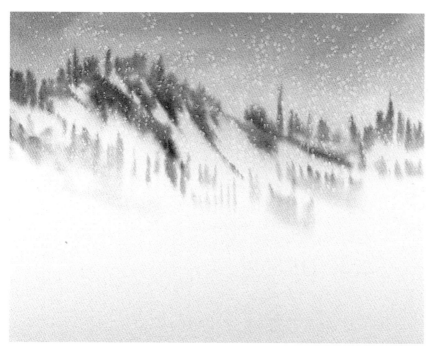

Step 1
Start on shiny-wet paper. Paint the overcast sky with a mix of Burnt Sienna and a slightly dominant Ultramarine Deep. Load a 2-inch (5cm) slant brush with rich paint and little water. Using the water on the paper to blur the edges, paint the rhythmically placed rows of evergreens while holding the brush with the longhair side at the bottom. Use the same colors, but add Raw Sienna. Repeat the brushstrokes on the slopes as well.

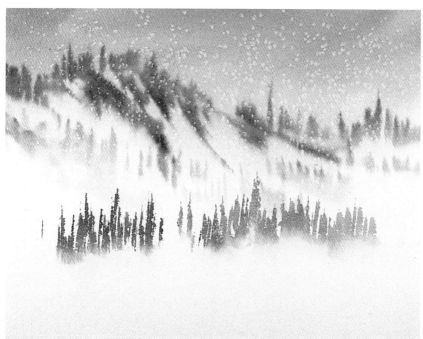

Step 2
While the paper is still damp, drop in the paler row of evergreens in the middle ground using the slant brush in the same way as in the first step.

Salt Technique
I used salt to create the snowflake effect. Sprinkle the salt just as the shine of your wash goes dull. It takes about fifteen seconds for the effect to show. After the paint has dried, brush off the salt. Practice first to get the timing right.

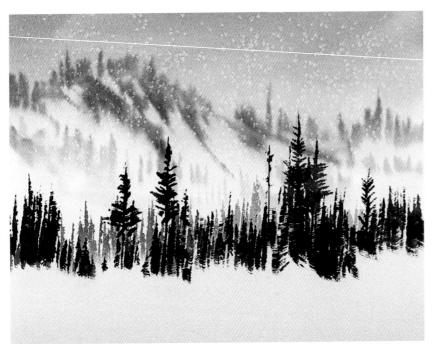

Step 3

Now the paper should be merely damp. Proceed with the darker group of trees. Note the variety in size and value. Add Cupric Green Deep to the other colors and watch the combined hue change slightly from stroke to stroke.

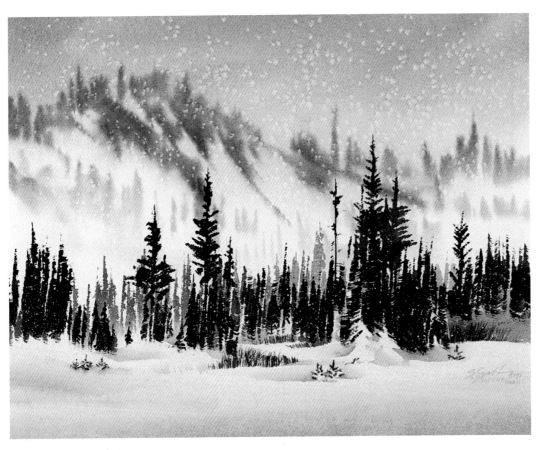

Step 4

Now the paper should be completely dry. Use a ¾-inch (2cm) flat aquarelle brush and continue with the finishing touches to the snow and larger trees that might need some final definition.

Misty Valley
15″×20″ (38cm×51cm)

Spruce

AVOID ARTIFICIAL PERFECTION
Spruce trees are tall and pointed. The small and young branches aim upward; the larger limbs point down because of the heavy foliage. The branches grow right to the ground. The elegant, formal appearance of the spruce tends to cause some artists to paint them with engineered symmetry. Try to avoid such artificial perfection.

DYING SPRUCES
Spruces are beautiful even when dying. The spotty foliage sometimes turns rusty brown, adding a splash of warm color. The exposed branches create a harmonious balance between line and tone.

PAINTING THE EDGE OF A SPRUCE FOREST
The edge of a spruce forest shows off the tapering nature of the trees. I painted this illustration on dry paper fast enough to allow the repeated brushstrokes to blend as they touched. While the color was still damp, I scraped out the light trunks with the tip of a slanted plastic brush handle. I touched the paper at an angle with a slant bristle brush loaded with rich paint, and rapidly repeated the brush marks to form the silhouette.

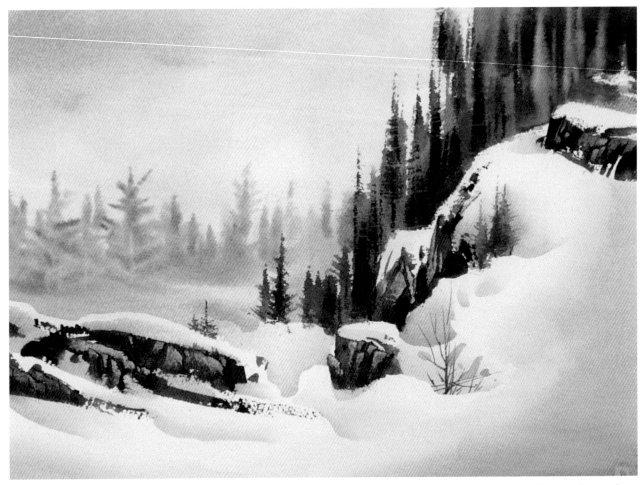

Here you see the edge of a spruce forest like on page 43 incorporated in a winter setting.

Candles on the Rocks
15" × 22" (38cm × 56cm)

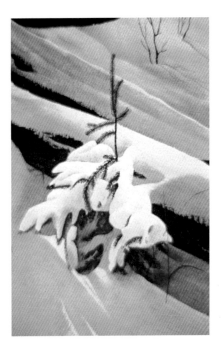

To paint this snow-covered spruce I started on dry paper with the shaded snow in the background. I used a 2-inch (5cm) soft slant brush and blended the top edges into the brightly lit peaks of the snow humps. I used this technique all the way to the bottom of the painting. I formed the snow-covered young spruce using the negative painting technique. The snow shadows are a mix of Raw Sienna and Primary Blue Cyan. The delicate spruce branches are Raw Sienna and Primary Blue Cyan applied with a no. 5 rigger.

Sheltered Spot
15" × 22" (38cm × 56cm)

Fir

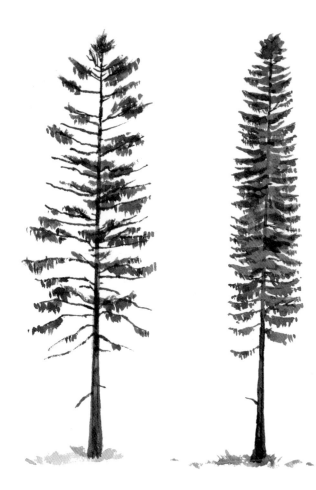

WEATHER-BEATEN FIR
Weather-beaten Douglas firs look scrawny from a distance despite their gigantic size. When exposed to the rugged climate, the branches are few and far between.

PROTECTED FIR
In a protected spot the same tree would look more symmetrical, with plenty of branches and lots of foliage.

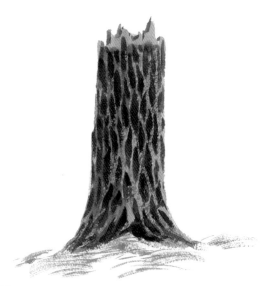

BARK
The bark of an adult Douglas fir is coarse with a large woven pattern. After you paint the dark hollow shapes, gently drybrush over everything to enhance the natural appearance.

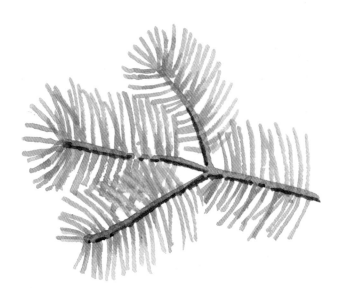

DOUGLAS FIR NEEDLES
Douglas fir needles are short and line up around the twigs. The immense number of needles are heavy, and they hang in a droopy manner from the branches.

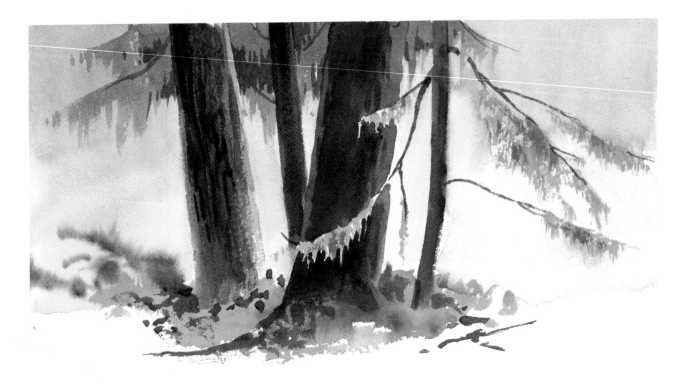

CLOSE TO THE GROUND

Here you can see that close to the ground, the lowest branches on a Douglas fir are the largest and have the heaviest concentration of foliage. The droopy characteristic is easy to see here.

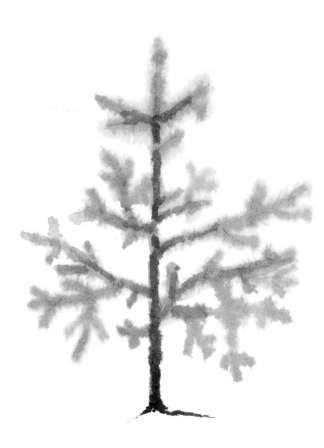

BABY DOUGLAS FIR

A baby Douglas fir looks likè a baby spruce. These delicate, fuzzy branches were painted on moist paper. I used a small rigger with rich paint and hardly any water in the brush. The moisture in the paper blurs the brushstrokes.

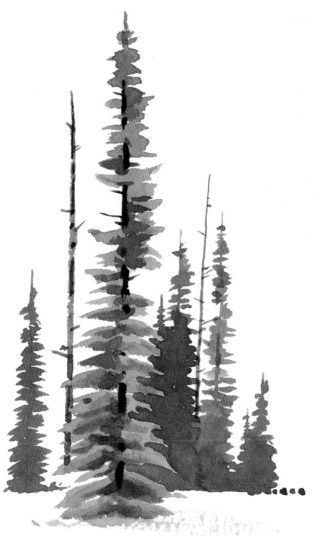

ALPINE FIR
The slim alpine fir grows in high elevations. The tree gently tapers toward a sharp point at the top.

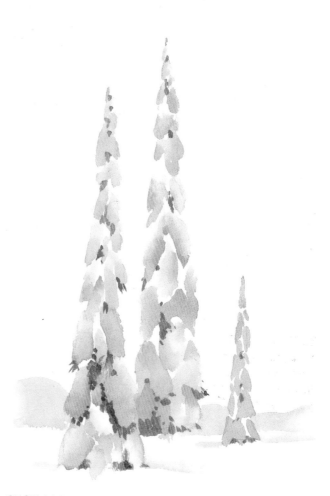

SNOW-LADEN ALPINE FIR
The weight of heavy snow further streamlines the taper, making the fir resemble a blue candle.

Monterey Cypress

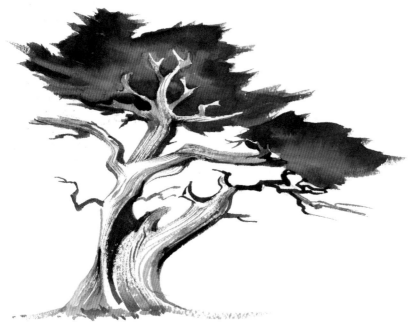

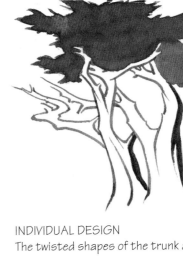

INDIVIDUAL DESIGN
The twisted shapes of the trunk and branches zigzag up to the heavy, dark foliage. Each individual tree has its own personal shape, proudly displaying its drastic design.

TWISTED TRUNK AND BRANCHES
A ghostly Monterey cypress with its characteristic twisted trunk and branches supports thick foliage at the tips of its branches. Use a split dry brush to paint the grainy pattern of the wood.

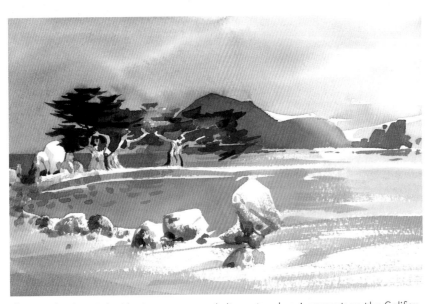

This study shows the Monterey cypress in its natural environment on the California coast.

This close-up detail shows the dry-brush grain on the branches. The brush needs to spread and form many small points, not one large one. Drag the brush, in this position, fast enough to touch only the peaks of the paper.

Cedar

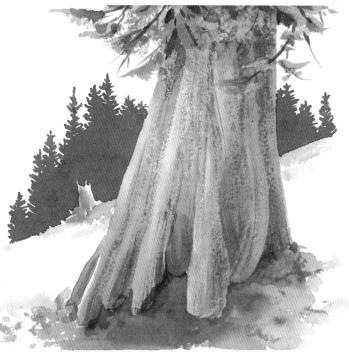

RED CEDAR
Red cedar has a chunky silhouette with heavy foliage hiding most of its branch structure. Wet-charge the shape with several thick brushstrokes of darker hues. Drybrush the lacy edges.

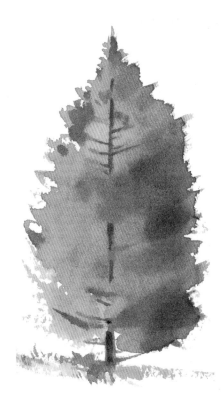

WESTERN CEDAR
The western cedar grows to a large size. The trunk is rough on the surface and forms a wavy circumference where it joins the ground.

RED CEDAR TWIGS
The leaves on a red cedar are like greenish twigs with many fingerlike points.

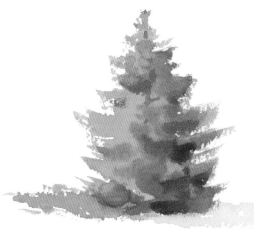

WHITE CEDAR
White cedar resembles a plump spruce, but the foliage is much thicker and fluffier.

WHITE CEDAR TWIGS
White cedar twigs are similar to those of the red variety, but are thinner and a little more abundant.

Palm Trees and Tropical Vegetation

A tropical climate is too hostile for most deciduous and coniferous trees. It's a perfect milieu for palms, however. These hardy and elegant-looking trees dress up a desert landscape and make an otherwise desolate terrain appear full of life and beauty. They are different from other trees, however. Rather than living in concentrated numbers—forests—palms are more individualistic and like more space around them. They work well as strong centers of interest or beautiful accents.

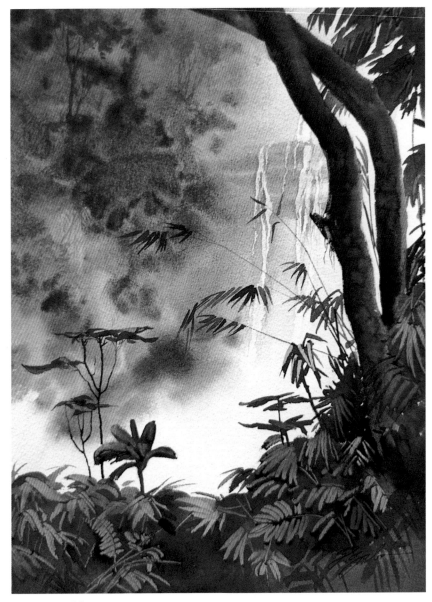

Maui's Trickle
15" × 22" (38cm × 56cm)

Coconut Palm

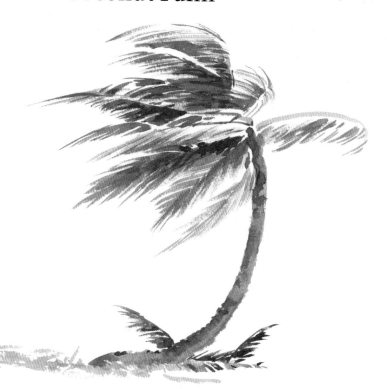

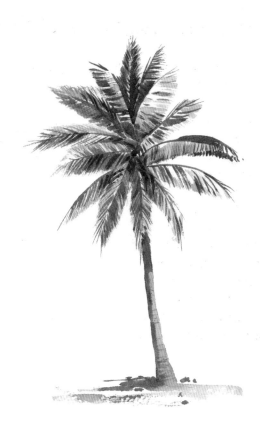

COCONUT PALM
Straight or curved trunks are natural characteristics of this family of palms. The branches consist of soft rows of pointed leaves that can withstand hurricane-strength winds and survive.

PROTECTED COCONUT PALM
When coconut palms grow in a protected area, their trunks are straight and the branches grow like cogs in a wheel.

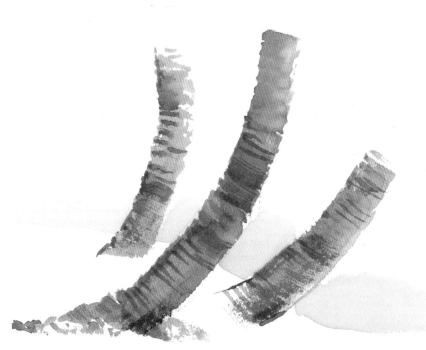

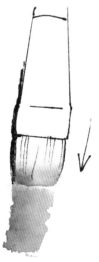

PALM TRUNK
The surface of the coconut palm trunk is smooth but shows ringlike growth marks.

PAINT THE BARK
To paint the bark as shown here, I used a medium-wet, soft, flat aquarelle brush loaded with half dark and half light color. Use repetitive brushstrokes, starting each a little into the one before. Make sure the brush holds very little water so the ring marks will survive.

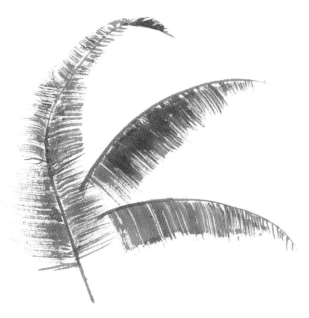

COCONUT PALM BRANCHES
The dry-brush technique is fast and effective for the branches.

DRY-BRUSH TECHNIQUE
Use a scarcely moistened slant bristle brush held at a low angle and rapidly pull while applying even pressure to create the coconut branches.

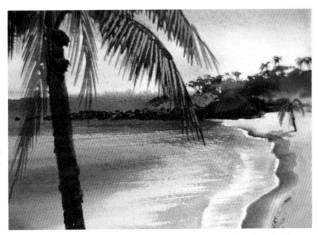

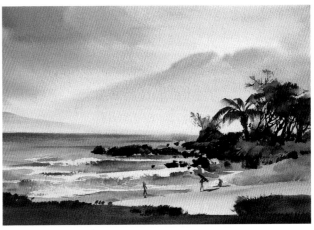

I started with the sky at the back using Cobalt Blue Light and a little Cupric Green Deep. I mixed Burnt Sienna and Cupric Green Deep for the group of trees at the back, then added some Permanent Violet Bluish in the darker areas. The water is a combination of Cupric Green Deep, Cobalt Blue Light and Raw Sienna. The sand is Raw Sienna and Permanent Violet Bluish. I used a 2-inch (5cm) soft slant brush to this point. To complete the painting I painted the large palm up front using the same colors as on the other trees. I applied the washes with a 1-inch (2.5cm) flat aquarelle brush.

Molokai Shores
15″ × 22″ (38cm × 56cm)

I painted the sky and distant mountain on wet paper with a 2-inch (5cm) soft slant brush using a wash of Cobalt Blue Light with a drop of Cupric Green Deep. Next, I painted the water area using the same colors, but with Raw Sienna added. For the sandy beach I used Raw Sienna and Permanent Violet Bluish. I switched to my 1-inch (2.5cm) flat aquarelle brush to finish the dark wall at the bottom. I chose Permanent Violet Bluish, Burnt Sienna and Cupric Green Deep for my dark color.

Distant Maui
15″ × 22″ (38cm × 56cm)

Palmetto

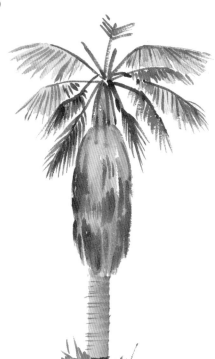

PALMETTO
Palmetto branches have long stems and fan out like dusting brushes. When they die they stay on the growing tree, but fold down creating a petticoat formation of dead branches. I painted the branches with a pointed no. 12 brush and the trunk with a ¾-inch (2cm) aquarelle brush filled with split colors—half the brush with one color, half another color. The resulting single brushstroke shows both.

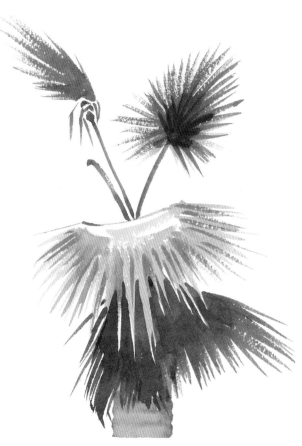

TRIMMED BRANCHES
If the dead branches are trimmed, their stubs create a decorative pattern, shown here, rather than the petticoat shape.

The branches are light in the sunlight, but may appear dark when shaded.

Saguaro Cactus and Joshua Tree

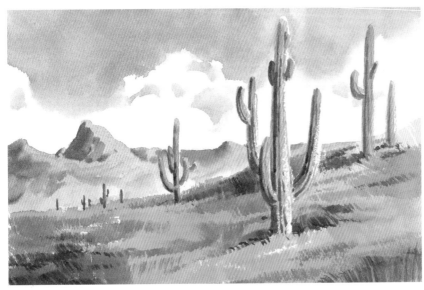

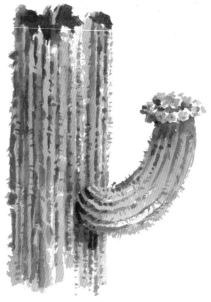

SAGUARO CACTUS
These cactuses live in the desert. They grow as tall as trees and live a long time.

SAGUARO TRUNK AND BLOSSOMS
The vertical grooves found on the trunk and the arms are rhythmically parallel and covered with prickly needles. In the spring, blossoms come out at the top of the cactus and at the tip of all branches, looking like bonnets.

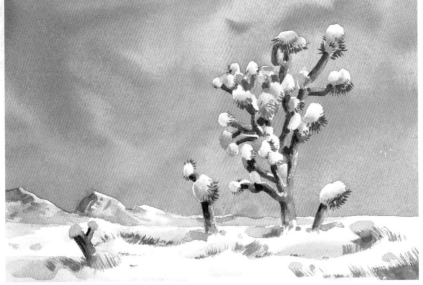

JOSHUA TREES
These cactuses look like stumpy trees and live only in a few places in the desert, like Joshua Tree National Monument in California. At the tip of each branch a prickly clump of needles grow, trapping lots of snow in the winter.

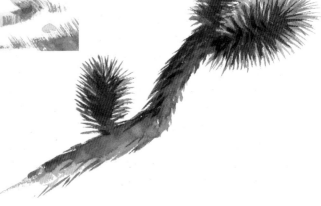

JOSHUA TREE BRANCH
Flat-lying prickly needles form a furlike covering on the surface of the pulpy branches.

Step by Step: *Forest's Edge*

COLORS

Permanent Green Yellowish Raw Sienna Permanent Violet Bluish Cobalt Blue Light Cupric Green Deep

Step 1

On a dry surface mask out vertical shapes for future light tree trunks; use strips of masking tape cut to varied widths. Also mask out a few thin branches using latex masking fluid. After masking, wet the paper and apply a few background colors in a very light value. Use a 1½-inch (4cm) soft slant brush lightly filled with Permanent Green Yellowish and Raw Sienna for the middle ground and Cobalt Blue Light and Raw Sienna for the misty background mountain.

Step 2

While the masking is intact, establish the middle-ground trees using Permanent Green Yellowish with Raw Sienna for the bright green foliage and Cupric Green Deep and Permanent Violet Bluish for the darker evergreens. Before these washes dry, carefully peel off the masking tape without tearing the surface. Later when the surface is completely dry, rub off the latex as well. The light foreground trees will be exposed as pure-white negative shapes.

Step 3

Using a ¾-inch (2cm) aquarelle brush, paint the tall trees with Raw Sienna and Cobalt Blue Light as a base wash and drybrush the bark texture later with Permanent Violet Bluish, Raw Sienna and Cupric Green Deep. Only the grassy foreground remains.

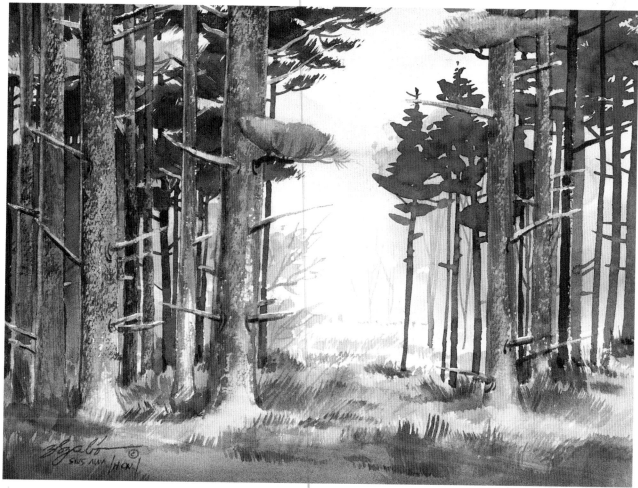

Step 4

To complete the painting, switch to a 2-inch (5cm) slant bristle brush and paint the clusters of grass starting with a rich mix of Permanent Green Yellowish and Raw Sienna, and adding Permanent Violet Bluish and Cupric Green Deep for the darker shades. Make small detail corrections as needed.

Forest's Edge
11″×15″ (28cm×38cm)

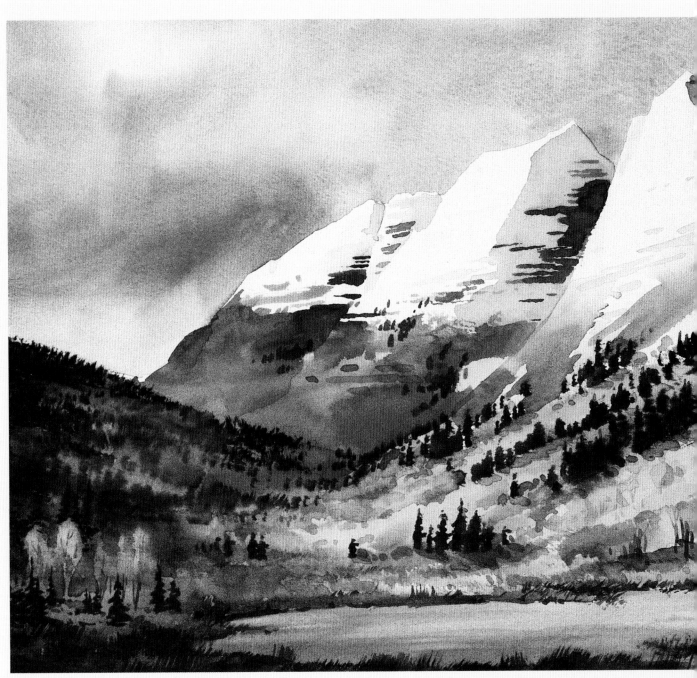

High Spring
11″×15″ (28cm×38cm)

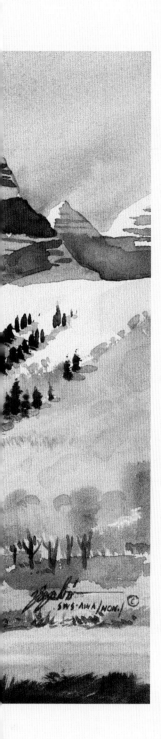

MOUNTAINS

Man has often thought of mountains as the spiritual key to the mystery of life. Mythology is full of gods who lived in mountains. The association of the gods and their homes—the mountains, also powerful—indicates the respect mankind has for mountains. As landscape subjects they are unsurpassed. Because we often see them from a distance—blue and misty—they automatically add the illusion of depth to a painting. Because constant changes occur on mountains, any creative change portrayed by an artist usually feels natural and believable. Mountains can provide a great setting for closer objects or become a dramatic center of interest themselves. Distant mountains have only one enemy—detail. Atmospheric conditions simplify their shapes and filter out details, so add details sparingly. You cannot paint mountains too simply, but it's easy to paint too much detail.

Tips for Painting Mountains

While there are no absolutes for a truly creative artist, there are some practical shortcuts that result from learning and experience.

1. Cool, transparent colors like Phthalo Blue, Phthalo Green, Phthalo Violet, Primary Blue Cyan, Antwerp Blue, Turquoise Green, Cupric Green Deep and Permanent Violet Bluish work well on mountains in the middle ground because of their intensity and ability to go dark and stay clean.
2. The more misty distant mountains get a softer atmospheric feel with diluted, reflective colors like Cobalt Blue Light, Ultramarine Deep and Cerulean Blue.
3. Earth colors supply good neutralizing complements, but only when mixed in diluted, thin liquid consistency. When reflective and earth colors are thick, they go muddy and lifeless.
4. Avoid details on faraway mountains.
5. Don't use harsh tools like a palette knife or the tip of a brush handle for distant mountains. They create hard texture that belongs only on closer shapes.
6. Above all, go simple in the distance.

In each of the illustrations here the colors are severely limited and tonal value becomes the most important component. On three the mountains are represented with negative shapes (light against dark). On the other three they are positive (dark against light).

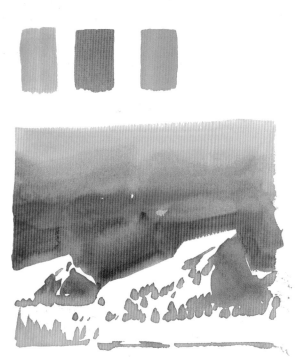

My three-color palette here was a combination of two warm colors and one cool. I used Permanent Yellow Deep, Verzino Violet and Cupric Green Deep. I started the sketches on dry paper to get sharp edges. I applied the washes so quickly that they easily blended with each other. For the tree shapes I used very little green and a lot of yellow.

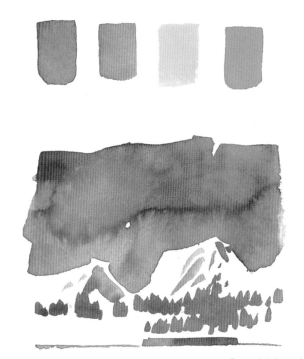

Verzino Violet, Cobalt Blue Light, Permanent Green Yellowish and Cupric Green Deep are the colors used in this study. For the sky area I wet-charged the colors into each other and left them as they oozed.

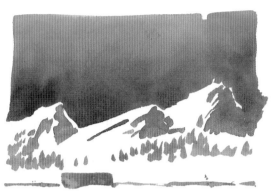

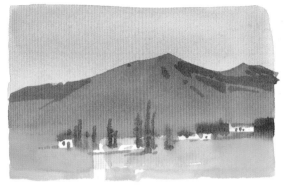

For this study I chose Cobalt Blue Light, Verzino Violet and Cupric Green Deep. Although I wet-charged a little green and violet into the sky, blue remained the dominant color.

Here I painted the Cobalt Blue Light sky first. After it dried I painted the mountain with Cupric Green Deep and Permanent Violet Bluish. I indicated the foreground with a mix of Cobalt Blue Light and Cupric Green Deep. The darkest shapes are a mixture of all three colors with the violet the strongest.

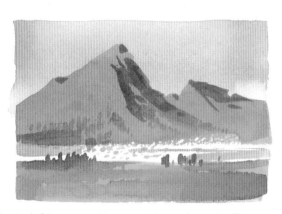

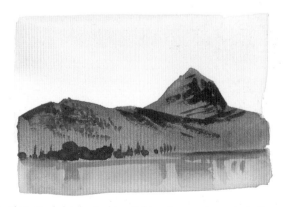

I started this mountain scene with a pale wash of Permanent Violet Bluish for the sky. After this dried I followed with the shapes of the mountains using a mix of Cupric Green Deep and Permanent Violet Bluish. The green foreground is Cupric Green Deep and Burnt Sienna. I did the little orangy color patches with a Burnt Sienna glaze after everything was dry.

For this study I selected two light colors and one dark: Permanent Yellow Deep, Permanent Green Light and Permanent Violet Bluish. I painted the sky with a wet-charged pale wash of green and yellow. After drying, I added violet to the mix and painted the mountains in medium value with the violet dominant. The foreground is green and yellow in a stronger value than the sky. For the rocky modeling on the mountain I used all three colors with violet the strongest.

Distant High Mountains

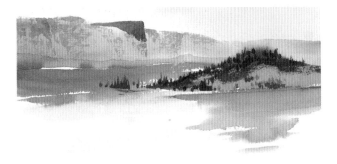

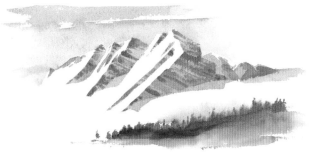

WARM COLORS
Warm colors dominate this quick study. I used Raw Sienna, Permanent Violet Bluish and Cupric Green Deep. The muted blues are the result of mixing Permanent Violet Bluish and Cupric Green Deep together.

COOL COLORS
I used Primary Blue Cyan, Raw Sienna, Verzino Violet and Permanent Violet Bluish for this cool-color-dominated study. The white snow exaggerates the natural rhythm of the mountain, as shown here on the Flatiron Mountains near Boulder, Colorado.

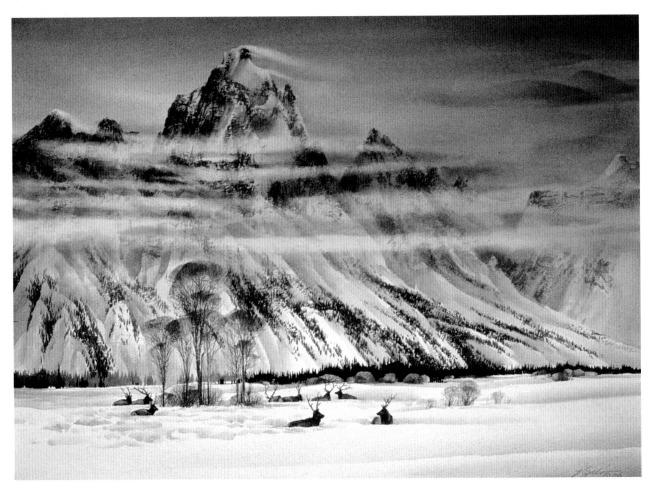

Warm colors dominate this watercolor. I painted most of the shapes with a conventional, direct painting method except for the low hanging clouds. After everything was dry I lifted the low hanging clouds out with a very wet, soft brush. First I loosened the paint by wet-scrubbing it and immediately blotted it up with a tissue.

Grandeur
22″×30″ (56cm×76cm)

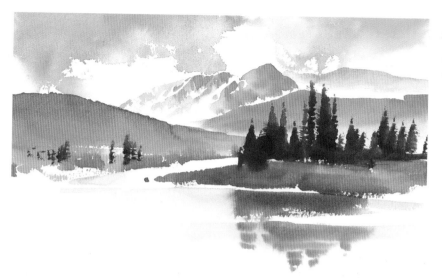

WARM AND COOL COLORS
The color temperature in this study is divided between cool and warm, with the cool colors slightly dominant.

Both cool and warm colors enhance this painting. Details are at a minimum because of the distance involved. The soft, large sky was created with a wet-into-wet technique using a 2-inch (5cm) soft slant brush. The snow-covered peaks next to the dark sky stand out in high contrast and create the focal point of the painting. Scale causes a convincing illusion of depth here despite the reduced value variety.

Big Sky Country
22″ × 30″ (56cm × 76cm)

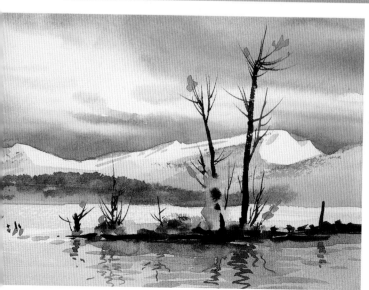

The large negative shape of the distant mountains plays a complementary role in this composition. The mountains are defined in light value and very cool colors. This simple combination sets off the colorful shrubs and trees in the foreground. I painted the sky and mountains first with a wash of Cupric Green Deep and Cobalt Blue Light using a 2-inch (5cm) soft slant brush. Next, I dropped in the long, darker land point directly in front of the mountains. I finished the bright shrubs and the tree trunks with a ¾-inch (2cm) aquarelle brush. The reflections on the water came last.

Early Snow
15″ × 22″ (38cm × 56cm)

Middle-Ground Mountains and Hills

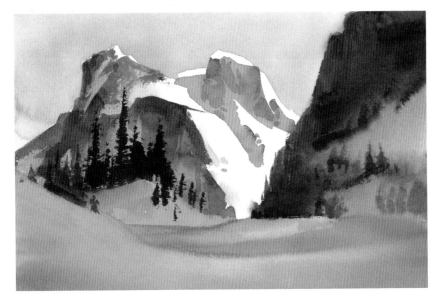

MIDDLE-DISTANCE MOUNTAIN
This study shows a mountain at mid-range rather than in the distance. Some details are hinted at here. The simplicity of the sketch is due to the colors. Permanent Violet Bluish and Cupric Green Deep supplied the blues, greens and shaded rock colors. Orange Lake is responsible for the warm glow behind the evergreens; it provides the darkest value when mixed with the other two colors.

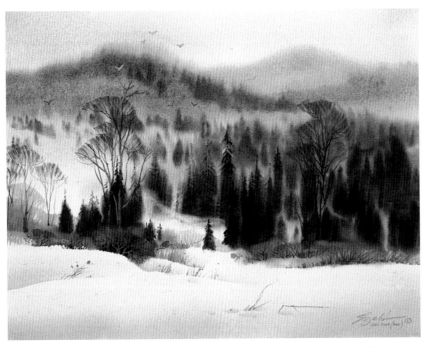

I started this painting on wet paper. For the soft colors of the sky and the basic tones of the distant mountains I used my 2-inch (5cm) soft slant brush. I painted the distant forest and all the evergreens with the edge of a 2-inch (5cm) slant bristle brush loaded with very rich paint and hardly any water. I charged the reddish shrubs into the wet, dark tree shapes using the same brush with Raw Sienna and Primary Red Magenta mixed. I switched back to my soft slant brush for the soft snow in the foreground.

Moody Day
15″ × 22″ (38cm × 56cm)

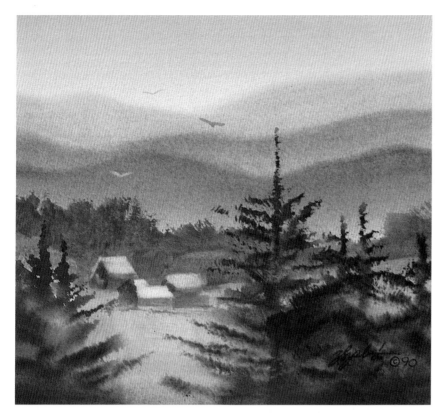

I painted the layered mountains on wet paper. My 2-inch (5cm) slant brush had paint only on the longhair half. As I applied the layers from the back, the brush defined the top edges and lost the valley side of the brushstrokes. The washes were Ultramarine Deep and Burnt Sienna in varied dominance. The details in the middle ground and the large spruces up front are warmer in color and dark in value.

Smokies
11″ × 15″ (28cm × 38cm)

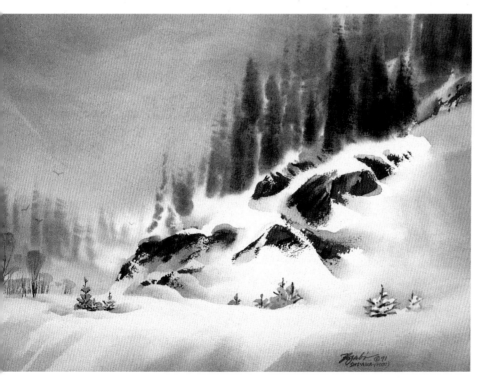

On a wet surface, I started with a Raw Sienna wash for the warm glow using my 2-inch (5cm) soft slant brush. I switched to a 2-inch (5cm) slant bristle brush to do the tall evergreens, adding a little Cupric Green Deep here and there. After the paper dried, I painted the rocks in the snow with Burnt Sienna and Ultramarine Deep, applied with a ³⁄₄-inch (2cm) aquarelle brush and textured with my palette knife. With the same brush and colors, I painted the shaded snow humps. I glazed the deciduous trees on the left with a no. 5 rigger, adding a little Cupric Green Deep to the snowy young spruces.

Winter Mood
15″ × 20″ (38cm × 51cm)

Snowy Peaks

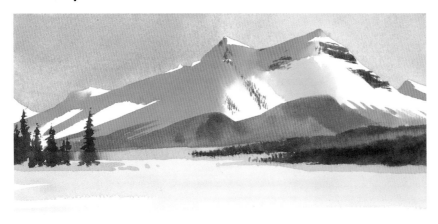

SNOWY SLOPES AND PEAKS
To achieve the illusion of high mountain sunlight and shadow on snowy slopes and peaks, keep the lit area white and the details on it warm. Paint the shadows very intense. I chose Green Blue, Ultramarine Deep and Burnt Sienna for this sketch. I applied the sky and snow-covered ground with a mix of blue and some Burnt Sienna in varied values. The dark forest color came from a rich combination of the two blues and Burnt Sienna.

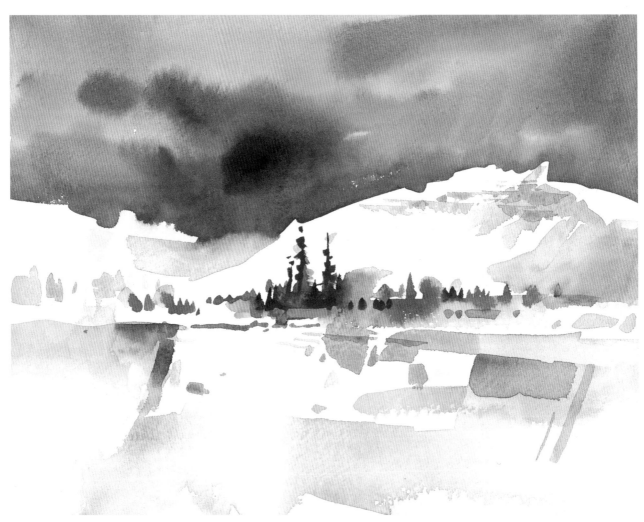

HAVE FUN
I had a little fun with this two-color rendering of an imaginary mountain scene and recommend you try something similar. Permanent Green Yellowish and Ivory Black made up my limited palette. I used both colors throughout the sketch, lavishly mixing them everywhere. The Ivory Black dominates where the darkest darks and the lightest lights create the greatest contrast because of its ability to stay dark. The green supplies color excitement.

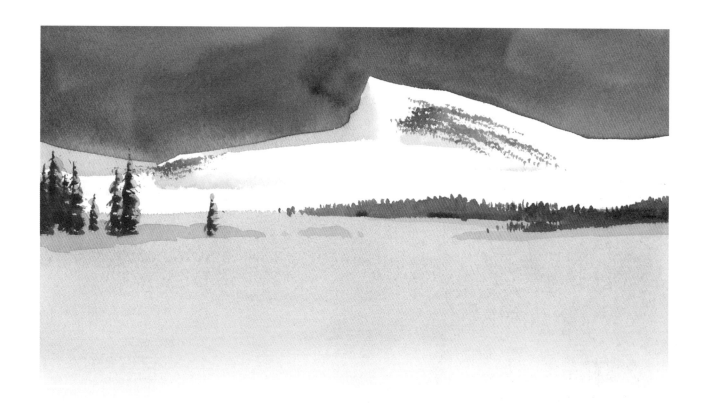

SNOWY PEAK

I used Permanent Violet Bluish, Cupric Green Deep and Burnt Sienna for this example of a snowy mountain. I started with the dark sky using the green and violet in a loosely mixed wash. The shading on the mountain and the snow-covered lake in front resulted from a graded light wash of green and violet. The sunny details on the slopes of the mountain are Burnt Sienna. The trees and the forest came last in the same colors as for the dark sky.

Mountains in Clouds

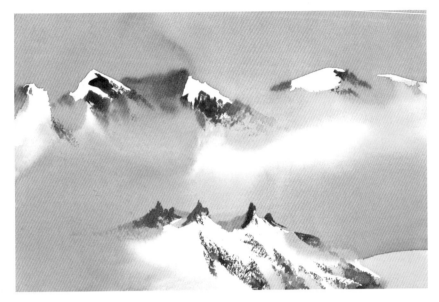

CLOUDY MOUNTAINS WITH
TWO COLORS
Using a 2-inch (5cm) soft slant brush
and only two colors, Cupric Green Deep
and Permanent Violet Bluish, I painted
the cloudy background fast enough for
the wash to blend into one color, while
saving the white of the paper for the
white peaks sticking out above the
clouds. I softened some of the edges
with a thirsty 1-inch (2.5cm) slant bris-
tle brush to give the illusion of thinning
mist. After the paper was dry, I estab-
lished the dark, snow-free rocks by dry-
brushing a mix of both colors in a very
dark value with my ¾-inch (2cm) aqua-
relle brush.

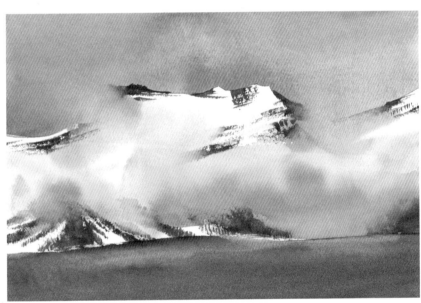

CLOUDY MOUNTAIN WITH THREE COLORS
I chose Burnt Sienna, Orange Lake and Cobalt Blue Light for this study. I started
on dry paper with a fast wash of Cobalt Blue Light and Burnt Sienna in varied domi-
nance. I carefully painted around the white mountaintops with a 2-inch (5cm) soft
slant brush. At the same time, I painted the floating clouds in the middle of the
mountain and blended the edges. After all this was dry, I treated the snow-free
rocks and trees with the same dry-brush technique as on the previous sketch, using
a ¾-inch (2cm) aquarelle brush. I finished the sketch with the foreground. I used
all three colors in my 1½-inch (4cm) slant bristle brush, with the two warm colors
dominant.

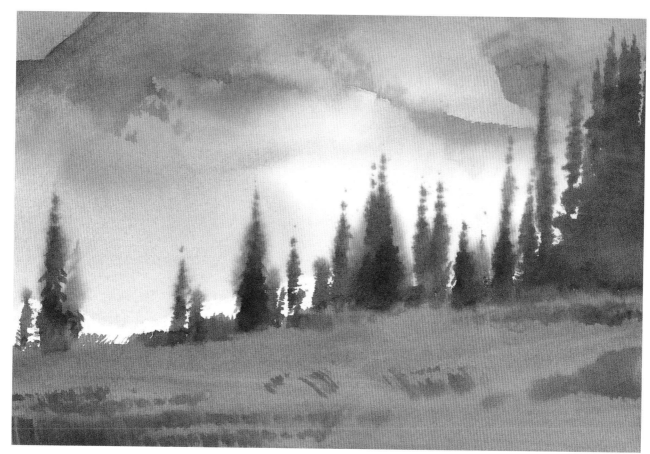

CLOUDY MOUNTAIN WITH FOUR COLORS

This scene was composed with Cobalt Blue Light, Cupric Green Deep, Permanent Yellow Deep and Burnt Sienna. I started with the shape of the mountain using a 2-inch (5cm) soft slant brush with a mix of Cobalt Blue Light and Burnt Sienna. I kept the top edge sharp but blended the bottom away. Next, I painted a graded wash with a 1½-inch (4cm) soft slant brush filled with a mix of Cobalt Blue Light and Burnt Sienna for the light bluish mist over the mountain.

While this wash was still moist, I sprinkled on the evergreens using a 2-inch (5cm) slant bristle brush filled with a very potent mix of green, blue and Burnt Sienna. I held the brush vertically with the short hair end facing upward as I repeatedly touched the moist surface. The tree shapes held, but the edges blurred a little. Using the same brush, I painted the grassy foreground with all four colors mixed and the yellow dominant.

Desert Mountains

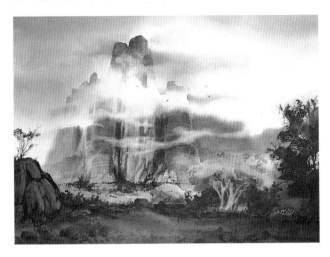

I began by painting the active clouds on a very wet surface. For the gray I mixed Ultramarine Deep and Burnt Sienna, but I allowed a little violet and some green to blend here and there. I used my 2-inch (5cm) soft slant brush for this. After this was dry I painted the large buttes using a 1-inch (2.5cm) aquarelle brush and a no. 5 rigger. I blended away the edges of the mountain to make the white cloud appear to be in front of the rocks. I used all five colors on my palette—Ultramarine Deep, Burnt Sienna, Cupric Green Deep, Raw Sienna and Permanent Violet Bluish—but the Burnt Sienna and Ultramarine Deep formed the strongest influence.

Next, I painted the middle-ground trees with Raw Sienna, Cupric Green Deep and Ultramarine Deep. For the shaded foreground I painted the large shadow shape with violet, green and a touch of Burnt Sienna. After this wash was dry, I glazed on the dark details with a more potent mix of the same colors using a ¾-inch (2cm) aquarelle brush. The dark and light contrast is the strongest and most recognizable characteristic of this painting.

Head in the Clouds
22″ × 30″ (56cm × 76cm)

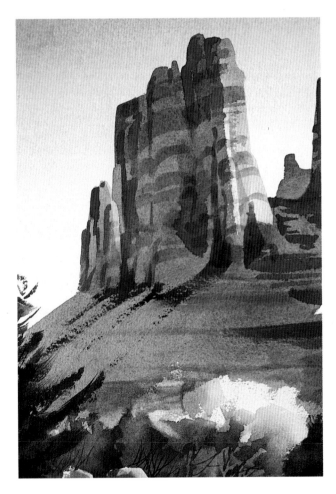

I started with the sky on wet paper. Starting from the top and with continuous movement, I painted the graded wash of the sky color mixed from Ultramarine Deep, a touch of Primary Blue Cyan and even less Burnt Sienna. Then I turned the paper upside down and repeated the technique with a touch of Cadmium Yellow Lemon and Burnt Sienna. I carried this wet wash into the other still-wet wash for complete blending.

After all was dry, I painted the sunny tone and the red rings of the butte using a 1-inch (2.5cm) aquarelle brush with Primary Red Magenta, Burnt Sienna and some Cadmium Yellow Lemon. After drying I glazed on the large shadow color moving my 2-inch (5cm) soft slant brush from the top downward fast enough not to disturb the reddish colors. For the foreground trees, I used all the colors except the magenta.

detail of *Desert Hero*
original 15″ × 22″ (38cm × 56cm)

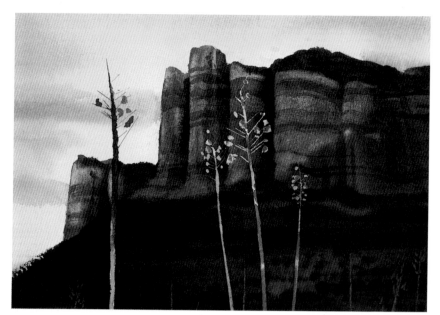

Again, I started with the sky on wet paper. The sky color is a light combination wash of Cupric Green Deep, Ultramarine Deep and a little Permanent Violet Bluish. After this dried I masked out the yucca plants and painted the reddish buttes with Orange Lake and Burnt Sienna, and added a little Permanent Violet Bluish to the Burnt Sienna for the rings on the rocks. Next I painted the giant shadow with Cupric Green Deep and Permanent Violet Bluish. After removing the masking, I completed the yucca with a ¾-inch (2cm) aquarelle brush and Raw Sienna, Cupric Green Deep and Permanent Violet Bluish.

detail of *Arizona Sunset*
original 22″ × 30″ (56cm × 76cm)

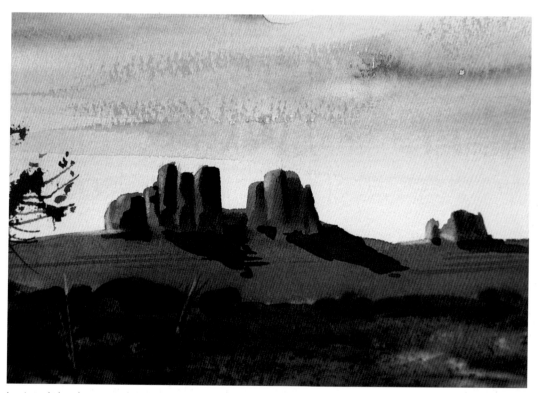

I painted the sky on wet paper using a 2-inch (5cm) soft slant brush filled with a very light combination of Cupric Green Deep, Cobalt Blue Light and a touch of Burnt Sienna. After this wash was dry I painted the silhouette of the buttes with Orange Lake, Verzino Violet and Burnt Sienna for the weakly lit rocks and added Cobalt Blue Light and Permanent Violet Bluish for the shaded area. I glazed the darkest shadows with a combination of Cupric Green Deep, Permanent Violet Bluish and Burnt Sienna.

detail of *Late in the Desert*
original 22″ × 30″ (56cm × 76cm)

High Peaks at Sunset

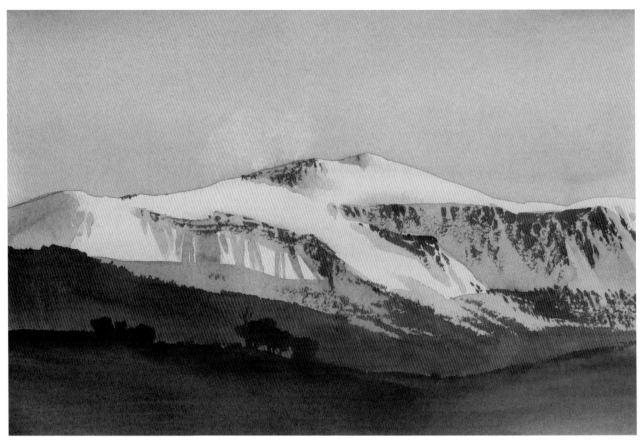

For this high peak at sunset, I covered the whole surface with a medium-strength coat of Permanent Yellow Deep. After this wash dried I painted a graded wash of Permanent Violet Bluish (dominant at the top) and Burnt Sienna (dominant at the bottom) for the sky. I used a 1-inch (2.5cm) aquarelle brush for the entire sketch. Next I painted the shaded section with Permanent Violet Bluish and Cupric Green Deep. After this was dry, I added the rocky texture to the side of the mountain and the indication of forest at the base with Permanent Violet Bluish and Burnt Sienna. My last glaze was the dark green foreground mixed from Cupric Green Deep, Permanent Violet Bluish and Burnt Sienna.

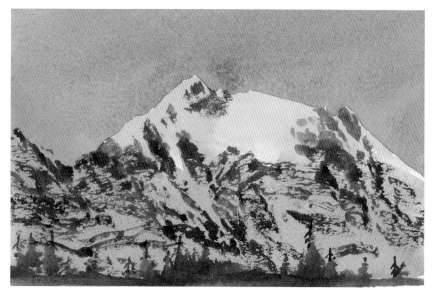

This is a small study, so I used a ¾-inch (2cm) aquarelle brush for the entire painting. On dry paper I started with the sky and the shaded part of the mountain using Permanent Violet Bluish and Green Blue. Next I painted the sunlit snow peak with a thin wash of Burnt Sienna. After this dried I drybrushed the rocky texture with Burnt Sienna. Notice that where the dry-brush color went on top of the sunlit area, the Burnt Sienna stayed warmer and lighter, so it looks sunny. Where it was glazed over the blue shadows, it combined with the blue and looks darker and cooler. I used dark blue for the trees last.

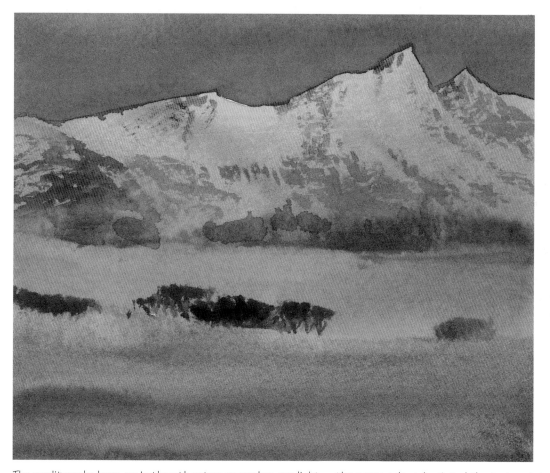

The sunlit peaks here, as in the other two examples, are light creating negative shapes. For this study I painted the top section of the paper with a medium wash of Tiziano Red. While the wash was still wet I painted some Green Blue into the pink. The edges blended softly. After drying I painted the sky around the mountains with Green Blue and Tiziano Red. With the same colors, I painted the texture into the shadows on the mountain. For the rocky texture in the sunny area I drybrushed Tiziano Red. Next, I used Green Blue and Burnt Sienna for the dark forest and meadow in the middle ground. The same colors were in my brush for the foreground, but the Burnt Sienna was stronger.

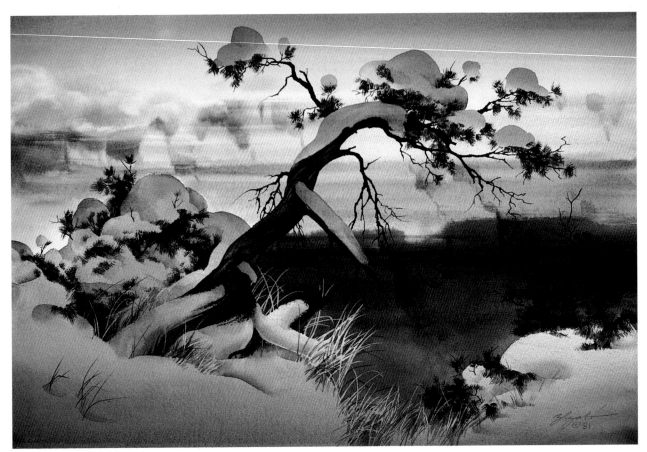

Show Stopper
15″ × 22″ (38cm × 56cm)

Although this isn't a mountain scene, it's a useful example. It's at the rim of the Grand Canyon, at a very high elevation, and gets treated much like a mountain when painting it. I started by painting a graded wash of the sky with Ultramarine Deep, Cupric Green Deep and some Burnt Sienna using a 2-inch (5cm) soft slant brush. Next I applied the base wash for the shaded snow in the foreground with the same colors in the same brush.

After this dried, I painted the base wash for the sunlit wall of the Grand Canyon using a light wash of Raw Sienna and Burnt Sienna. For the dark reddish layers in the rocks I used all the colors except Cupric Green Deep. When this was dry, I brushed in the dark tree and shrubs with a rich mix of Cupric Green Deep, Verzino Violet and Burnt Sienna in my ¾-inch (2cm) aquarelle brush.

Step by Step: *Liquid Emerald*

COLORS

Cupric Green
Deep

Cobalt Blue
Light

Permanent
Violet Bluish

Burnt Sienna

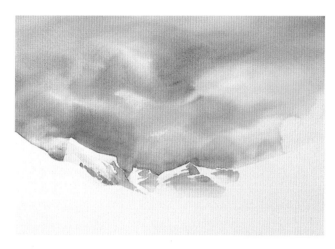

Step 1

On dry paper, paint the clouds with wet colors quickly enough for the brushstrokes to blend as they touch. This gives the sky a wet-into-wet look. Use a 2-inch (5cm) soft slant brush filled with wet Cupric Green Deep, Cobalt Blue Light and Permanent Violet Bluish in varied combinations. Stop the wash for the sky at the edge of the white mountains to define the jagged rim. Shade these shapes with a ¾-inch (2cm) aquarelle brush loaded with Burnt Sienna and Cobalt Blue Light.

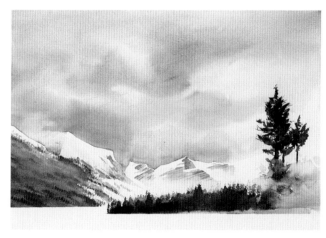

Step 2

Continue with the medium-value wash of the hill on the left side. Use all four colors in a 1½-inch (4cm) slant bristle brush; vary the mix, but make sure that the cobalt dominates the wash. The cobalt ensures that the color will stay pale and atmospheric. Follow with the forest-covered land point in a darker value. For the tall evergreens, use the four colors again, but with Burnt Sienna and Cupric Green Deep dominant. Below the tall evergreen use Burnt Sienna and Cobalt Blue Light to suggest a warm shrub and a hint of frost.

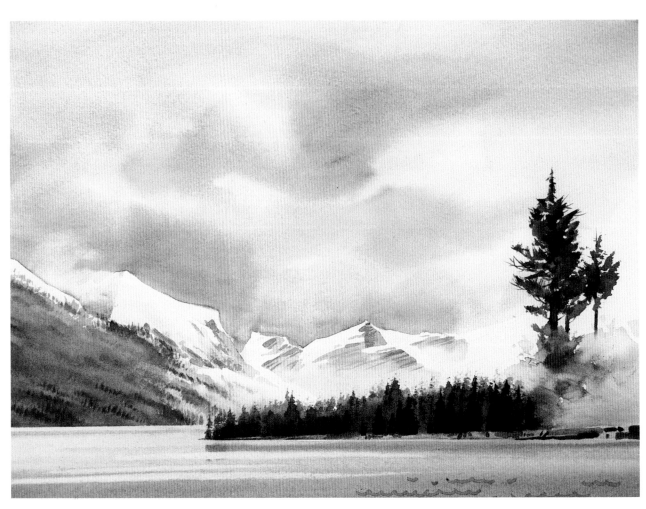

Step 3

Next, paint the emerald color of the lake. With horizontal strokes of a 1-inch (2.5cm) aquarelle brush, establish the color variation by using Cupric Green Deep, Cobalt Blue Light and a touch of Burnt Sienna. While this shape is still a little damp, lift the very light highlights with your brush. Forcefully squeeze the brush dry so that it is thirsty.

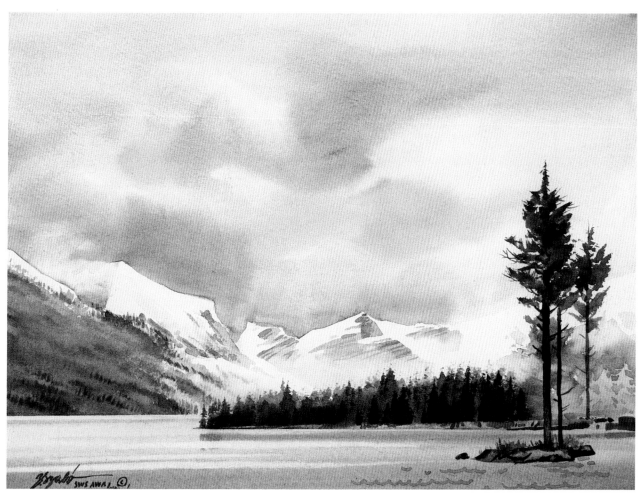

Step 4

Now it's time to paint the small island in the foreground with a 2-inch (5cm) slant bristle brush. Use all four colors with Burnt Sienna and Cupric Green Deep dominant. Finish the trunks and branches of the tall evergreen trees with a dark combination of Burnt Sienna, Permanent Violet Bluish and Cupric Green Deep, and tie them to the new island in the foreground.

Liquid Emerald
11″ × 15″ (28cm × 38cm)

Mountains With Glaciers

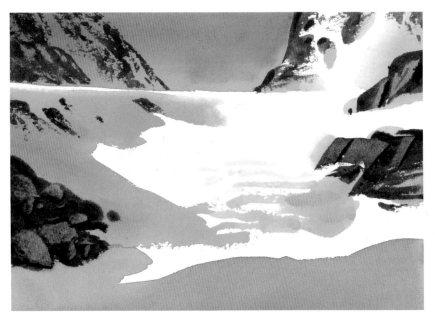

This is a view of a glacier at a high elevation, where the colors are vivid and the shadows are in dark contrast. I used my ¾-inch (2cm) aquarelle brush and later a palette knife. My colors were Ivory Black, Permanent Violet Bluish and Primary Blue Cyan (a strong staining color). I painted the rich blue washes with cyan and a touch of Permanent Violet Bluish. After this dried, I positioned the shapes for the exposed rocks with a very dark mix of all three colors, and while still wet I scraped off the lighter sides of the rocks with the firm heel of my palette knife.

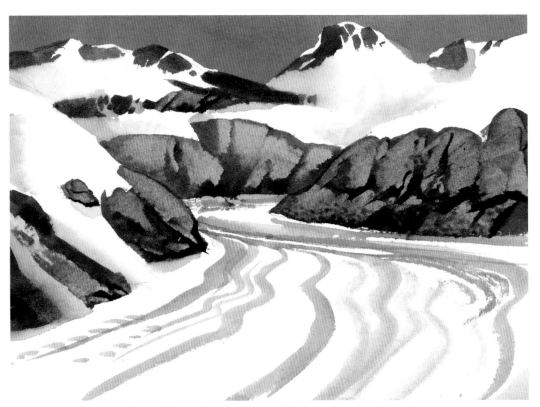

Here I used two colors, Green Blue and Ivory Black, with the same aquarelle brush and a palette knife. I began by painting the sky with a blue-dominated rich wash of both colors. I painted the exposed rocks sticking out from the snow and knifed out the light modeling with the heel of my palette knife. I defined the curving flow pattern on the glacier with repetitive wavy brushstrokes. I finished by painting the soft blended tones to shade the white snow.

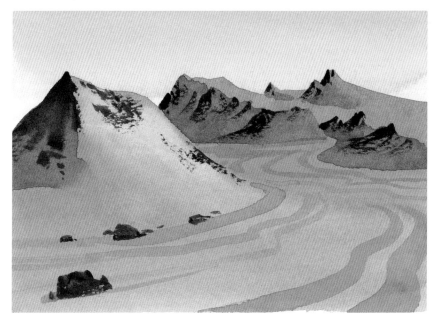

This illustration depicts a condition at sunset when the snow is shaded and appears darker than the sky (positive shapes). I used Raw Sienna, Green Blue and Verzino Violet with only my ¾-inch (2cm) aquarelle brush. I started the sky with Raw Sienna and shaded this wash with Verzino Violet near the top edge. After this dried I painted the base wash for the snow-covered area with all three colors, the Green Blue dominant. While this wash was still damp, I used a tissue to wipe off some color from the side of the largest peak. After all this dried, I glazed the darker shading on the peaks and the flow pattern of the glacier to boost the illusion of depth. I finished by dry-brushing the exposed rocks using all three colors in a very dark value.

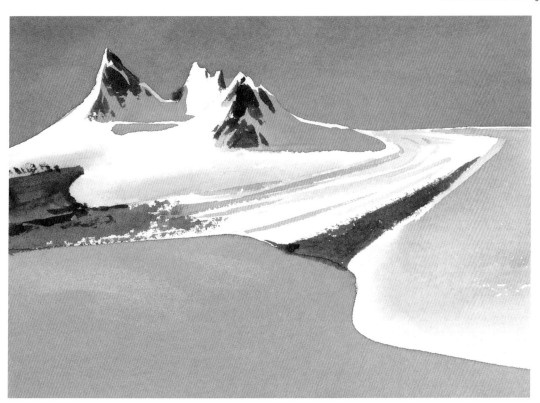

My colors here were Cupric Green Deep and Permanent Violet Bluish. I started with the sky using my ¾-inch (2cm) aquarelle brush and mixing both colors, with the violet dominant. For the snow shadows and the flow pattern of the glacier, I mixed the two colors in a light value, but for the exposed rocks and ground I used a very dark mix. At the end I painted the turquoise water with a lot of Cupric Green Deep and just a touch of Permanent Violet Bluish. Note that the highest contrast is at the exposed, sharp, snow-covered peaks.

Step by Step: *Melting Glacier*

COLORS

| Cupric Green Deep | Cobalt Blue Light | Permanent Violet Bluish | Burnt Sienna | Permanent Yellow Deep |

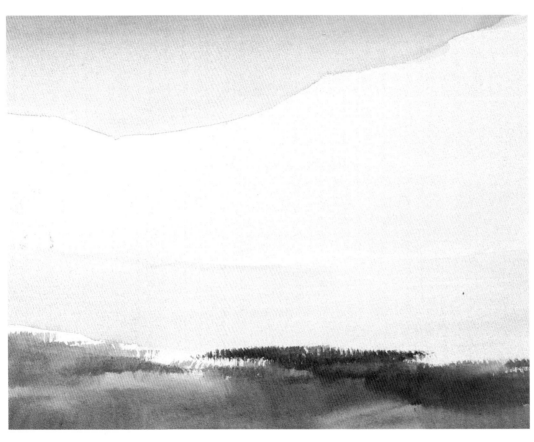

Step 1

Start on dry paper. Load a 2-inch (5cm) soft slant brush with strongly diluted color. Paint the sky with a little darker combination of Permanent Violet Bluish and Burnt Sienna, and blend it with a light creamy wash of Permanent Yellow Deep at the lower sky. Paint the base washes of the mossy foreground using a 2-inch (5cm) slant bristle brush. With the exception of Cobalt Blue Light, use all the colors in varied value and dominance.

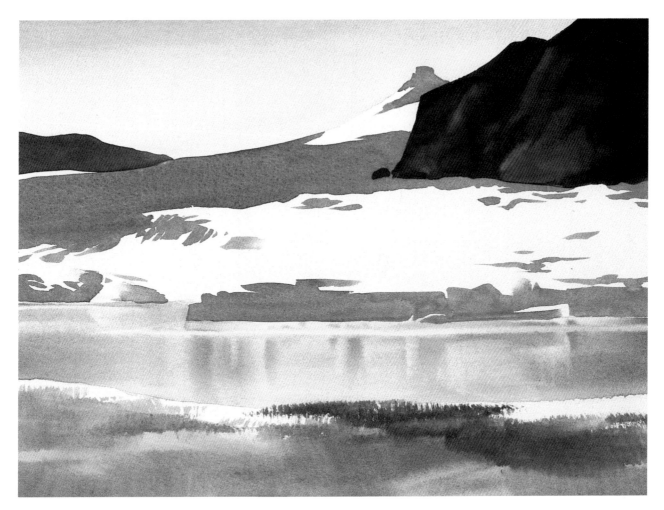

Step 2

Next apply the shaded snow and ice with a medium-dark wash of Cobalt Blue Light, Cupric Green Deep and a little Burnt Sienna. Paint the dark, massive rocks with a ¾-inch (2cm) aquarelle brush using all the colors except Cobalt Blue Light. Wet-charge these colors with each other to assure color variation within the dark shapes. Now paint the pale reflecting water as a wet-into-wet shape with Cobalt Blue Light, Burnt Sienna and a touch of Permanent Violet Bluish.

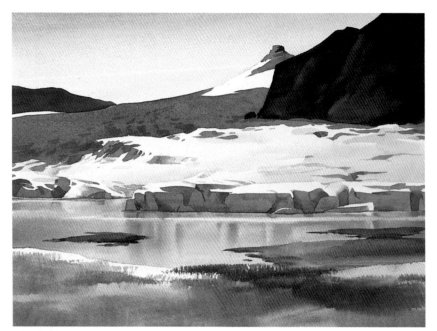

Step 3

Indicate the details of the glacier with accents of darker blue in the shadows and a little Burnt Sienna and Permanent Violet Bluish in the sunlit area. Also enhance the reflection and add a few small details to the mossy foreground as needed.

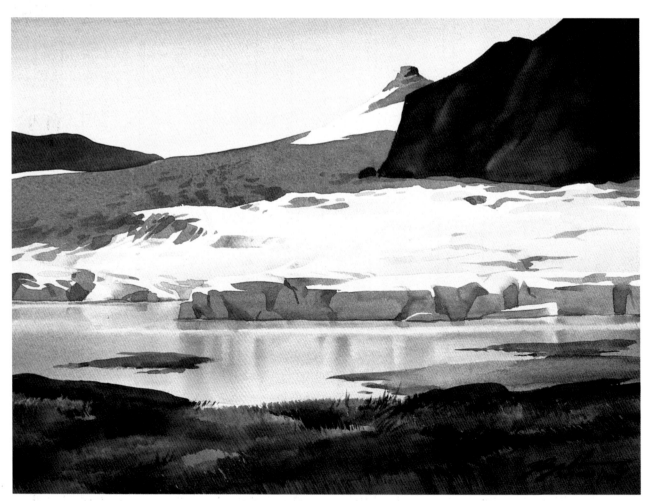

Melting Glacier
11″×15″ (28cm×38cm)

Step by Step: *High Spring*

COLORS

| Cobalt Blue Light | Permanent Violet Bluish | Burnt Sienna | Permanent Green Yellowish | Cupric Green Deep |

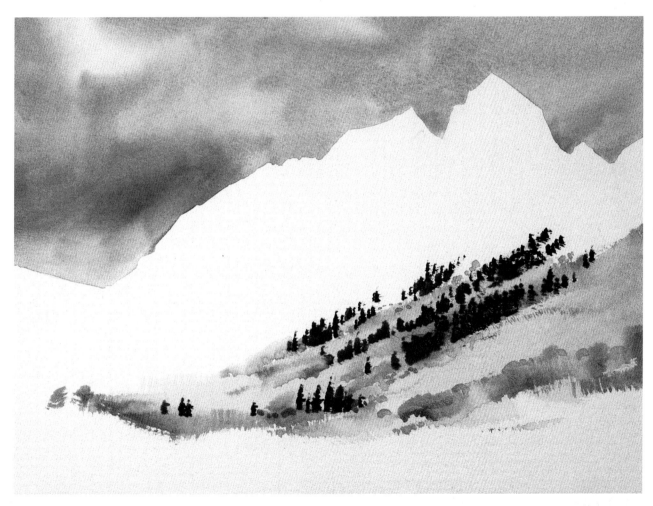

Steps 1 and 2

On dry paper, paint the sky as a light and very wet shape using a 1½-inch (4cm) soft slant brush. Apply the wash rapidly after defining the edge of the mountains. Use Cupric Green Deep and Permanent Violet Bluish for the blue portion and Cobalt Blue Light and Burnt Sienna for the darker cloudy area.

Next paint the springlike colors of the middle ground using light washes of Permanent Green Yellowish, a touch of Burnt Sienna and some Cupric Green Deep, using the same soft slant brush. While this wash is still wet, switch to a 1½-inch (4cm) slant bristle brush and dip the long end in a very dark mix of Burnt Sienna, Cupric Green Deep and a little Permanent Violet Bluish. Turn the brush so that the long end is at the bottom, and with quickly repeating contact, suggest the rows of evergreens.

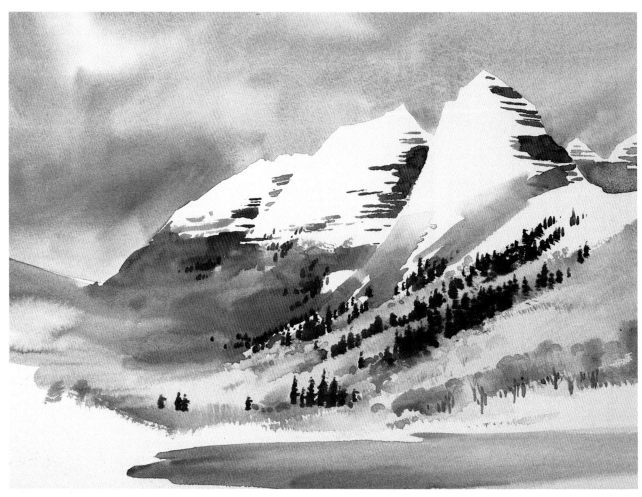

Step 3

Paint the exposed rocky part of the mountains up to the snow line. Carry the same color over to the left side slope as an underpainting using a 1-inch (2.5cm) aquarelle brush. After changing colors to Cupric Green Deep, Cobalt Blue Light, Permanent Green Yellowish and a touch of Burnt Sienna in varied combinations, paint the portion of the lake.

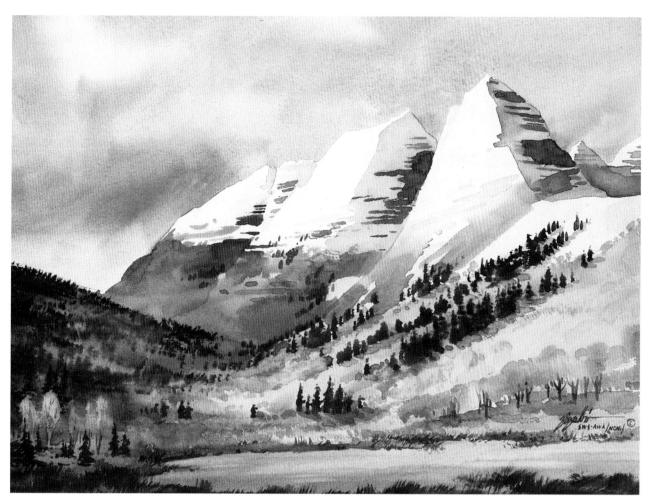

Step 4

With a slant bristle brush, paint the dark forest on the left side. Apply the dark grassy edges of the lake with the same brush using the same colors as for the evergreens on the other side. Paint the shaded sides of the mountains as well as the cast shadows of the trees over the sunny ground color. Mix this evenly applied wash with Cupric Green Deep, Cobalt Blue Light and a touch of Permanent Violet Bluish in a 1-inch (2.5cm) aquarelle brush. Complete the painting with a few light-green trees and their shadows just above the lake with Cobalt Blue Light and Permanent Green Yellowish.

High Spring
11″×15″ (28cm×38cm)

Step by Step: *Deep Winter*

COLORS

Burnt Sienna Cupric Green Cobalt Blue Permanent
 Deep Light Violet Bluish

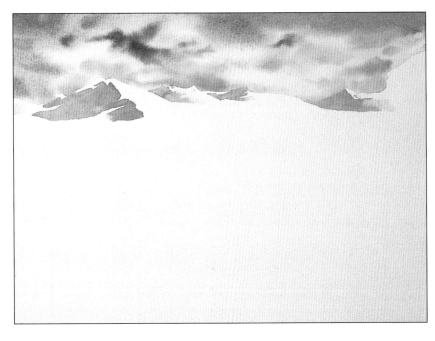

Step 1

Begin by wetting the sky portion of the paper. Using a 1-inch (2.5cm) aquarelle brush, proceed with light wet washes of Burnt Sienna, Cobalt Blue Light and a little Permanent Violet Bluish, allowing plenty of white paper to remain. The bottom edge of the wet sky defines the white mountain peaks. Paint the shaded sides of the mountains with Cobalt Blue Light and a little Burnt Sienna.

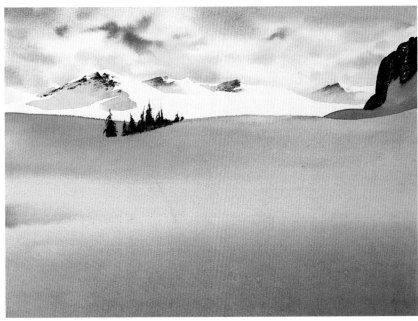

Step 2

Switch to a 2-inch (5cm) soft slant brush filled with a premixed combination of Cobalt Blue Light, Cupric Green Deep and Permanent Violet Bluish. Paint the entire shaded, snowy foreground as one wash, but vary the values to indicate changes in the terrain. Establish the distant row of trees and the protruding rock on the right side using Burnt Sienna, Permanent Violet Bluish and Cupric Green Deep in a dark value.

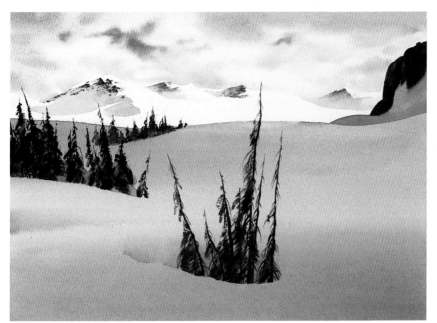

Step 3

With a 1½-inch (4cm) slant bristle brush, rough in the larger row of trees at the left edge as well as the weather-beaten alpine firs just off the foreground center. If the bristle brush leaves the bottom edge a little crude, smooth it with a rigger while the color is still wet. Except for Cobalt Blue Light, use all the colors in a dark value and varied dominance.

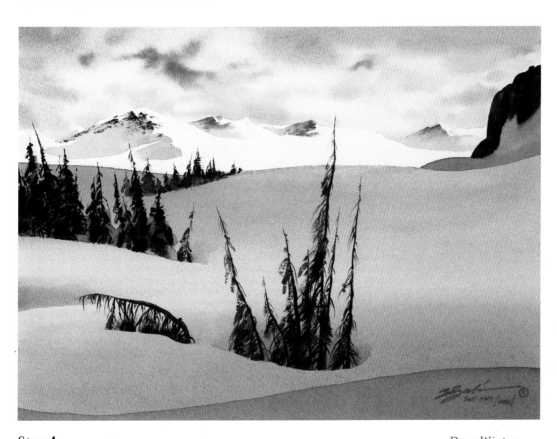

Step 4

Add a bent tree to the left of the large clump. Paint a curving shape on the bottom edge of the snowy field to indicate a darker drift; use a 2-inch (5cm) soft slant brush with Cupric Green Deep, Permanent Violet Bluish and a little Cobalt Blue Light. Finish the painting with some calligraphic refinements on the closer trees with a rigger as necessary.

Deep Winter
11″×15″ (28cm×38cm)

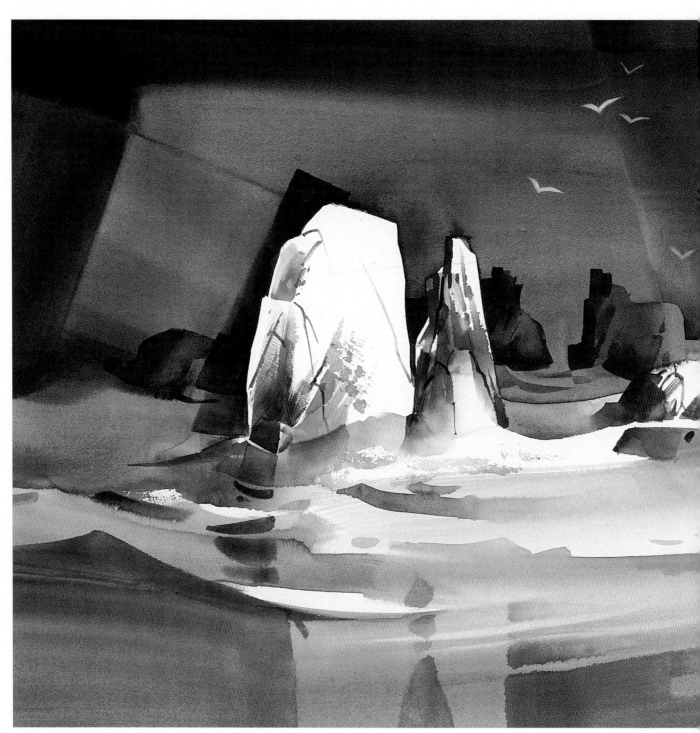

White Guards
22″×30″ (56cm×76cm)

ROCKS

Painting rocks means painting geological history. Their strength has fascinated mankind since the cave paintings through David's encounter with Goliath, from the pyramids to the marble statue of Pietà. When you use our Earth's oldest material for a painting subject, the treatment should allude to solidity, age, majesty and permanence. Rocks come in all colors from white to black. Some are smooth from erosion; some are jagged. Some are big (cliffs) and some are small (pebbles). Because they're everywhere, they can serve as a complement or center of interest in a landscape painting.

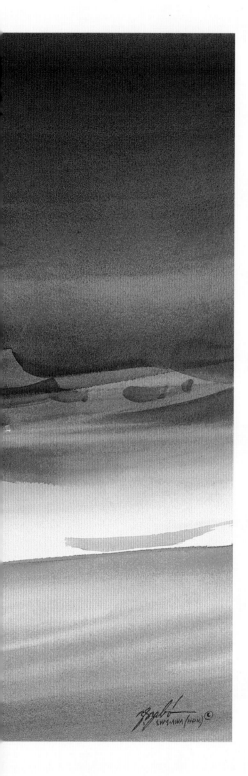

Jagged Rocks

JAGGED ROCKS

For basic jagged rocks, paint the dark shape of the rocks with a ¾-inch (2cm) aquarelle brush filled with a thick wash of Burnt Sienna and Primary Blue Cyan. While this wash is still tacky moist, scrape off the excess paint by pressing the heel of your palette knife into the paint repeatedly. Because the blue is more staining than the sienna, the shapes you knife out stay blue.

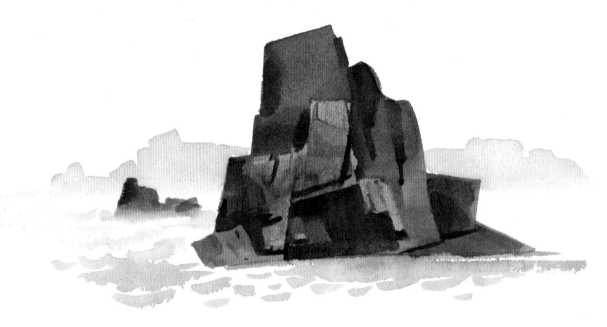

TIGHTLY FUSED UNITS

Occasionally, jagged rocks appear in a large, tightly fused unit. For this study, I used my ¾-inch (2cm) aquarelle brush and Cupric Green Deep, Burnt Sienna and Permanent Violet Bluish together as a dark wash. To prevent monotony you can vary the dominance of the thick wash from spot to spot. Also, scrape off the light sides of the rocks with the heel of your palette knife before the color has a chance to dry.

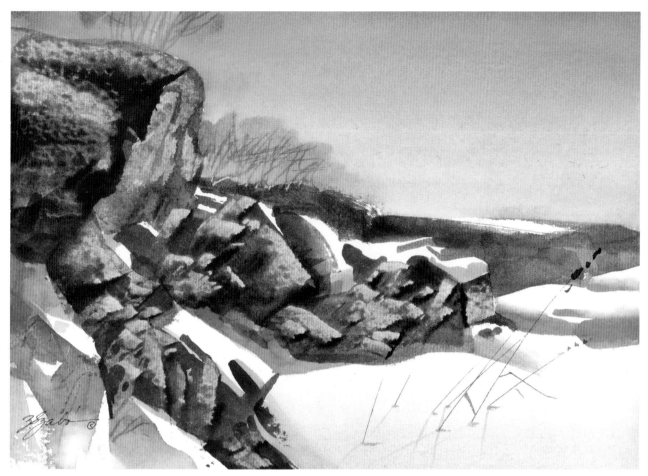

TWO-COLOR STUDY

I used Green Blue and Burnt Sienna as complements for this study. I started with a graded wash dominated by the Green Blue for the sky applied with a 1½-inch (4cm) soft slant brush. I painted the rocks with Burnt Sienna in sections to make sure the thick color stayed moist for knifing. To do this, hold your knife firmly with the wide part upward and press hard on the heel while slightly lifting the tip of the blade. This way you achieve, simultaneously, the lightest color at the top and a gradual darkening texture in the path of the knife.

Use Your Palette Knife

One of the best tools to use on rocks, especially close-up rocks, is a palette knife. The firm, wide heel of the blade is great for squeezing off moist, dark color and leaving a textured light tone on round glacial rocks and a cracked appearance on jagged surfaces.

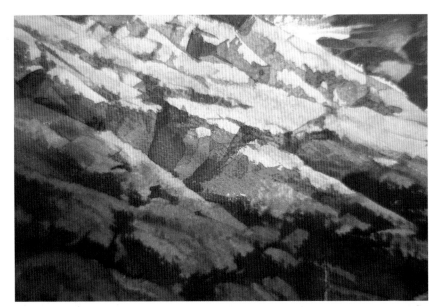

DETAIL OF ROCKS

You can see in this detail how I scraped off the top of the eroded soft rocks with the heel of my palette knife. I painted an underwash of Primary Blue Cyan for the shadow. When the underwash was dry, I painted large sections of the rocks with my 1-inch (2.5cm) aquarelle brush using Burnt Sienna, Raw Sienna and some Primary Red Magenta.

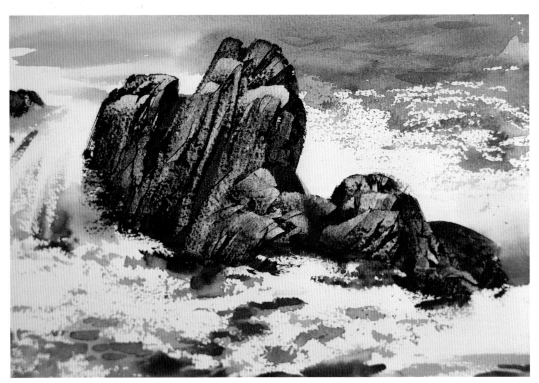

SAME TECHNIQUE, DIFFERENT COLORS

Here's another example of the same technique used for these rocks. The colors I used here are Permanent Violet Bluish, Burnt Sienna and Tiziano Red. For the sky and water, I used those colors and Green Blue.

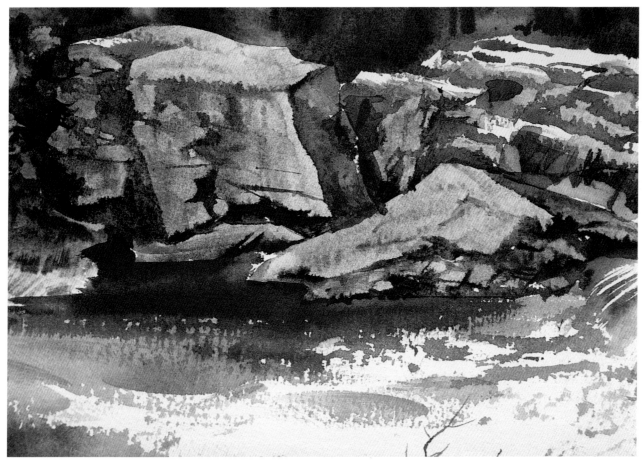

COMPLEX ROCKS
These rocks were painted exactly the same way as the two previous examples, except for the colors. Here I used Burnt Sienna, Ultramarine Deep and Permanent Violet Bluish for the rocks and added a little Cupric Green Deep to the glazes of the water.

Add Boldness
The strength of stone is a psychological attraction and usually adds boldness to a painting.

Rounded Rocks

SHAPE ROCKS WITH EVEN SPEED
I painted the shapes of these rocks using a rich, dark wash of Permanent Green Yellowish, Ultramarine Deep and Verzino Violet in a 1-inch (2.5cm) aquarelle brush. As soon as you put down the brush, scrape off the light texture. Hold the knife firmly, keeping the wide part upward. It's important to move the knife with an even speed from left to right for each rock shape.

GLACIAL ROCK COVERED WITH MOSS
I chose Verzino Violet, Green Blue, Raw Sienna and Permanent Violet Bluish for this study. For the base wash, I covered the rock area with a medium-light wash of Green Blue, Raw Sienna and a touch of Permanent Violet Bluish. To create a little form, I shaded this with Permanent Violet Bluish and its complement Raw Sienna. After all this dried, I sponged on the dotted texture with a natural sponge. I used four separate glazes with all four colors in varied combinations, and let each application dry thoroughly before applying the next one. I painted the cracks on the rocks last.

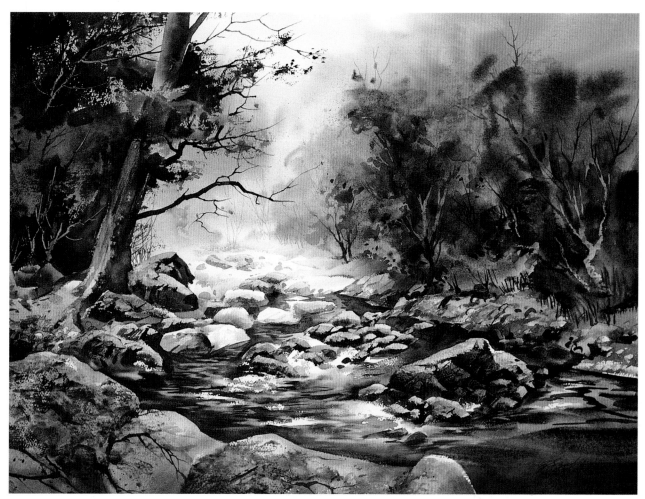

WET, SHINY ROCKS

After the background and foliage of this painting were dry, I painted the rocks onto the white paper two or three at a time. I used a ¾-inch (2cm) aquarelle brush filled with a rich mixture of colors dominated by darks such as Burnt Sienna or Permanent Violet Bluish. I scraped off the tops of the wet shapes with my palette knife, making them look like wet, shiny rocks.

River's Edge
22″ × 30″ (56cm × 76cm)

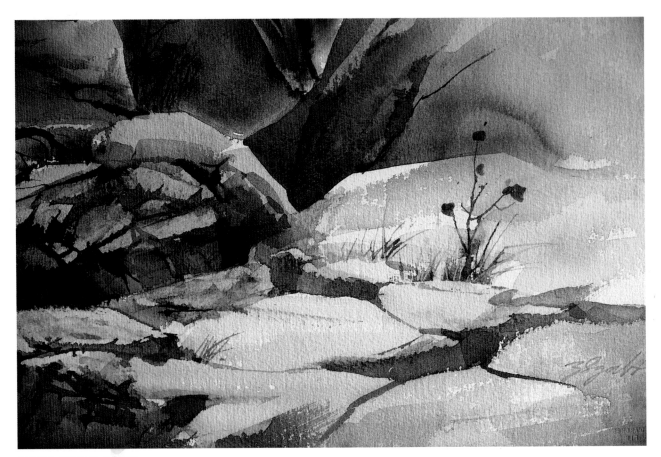

ROCKS, ROCKS, ROCKS

I applied a mixture of Burnt Sienna, Raw Sienna and some Ultramarine Deep with a 1½-inch (4cm) soft slant brush for the light color of the large smooth surface of the big flat rocks up front. I used the same colors for the background, but in a darker value. I made a dark mix of Burnt Sienna, Ultramarine Deep and Cupric Green Deep to paint the stacked up rocks on the left. After all this was dry, I finished the shaded cracks on the flat rock and the dark background with a ¾-inch (2cm) aquarelle brush. Then I touched up the cracks and painted the weed with a no. 5 rigger.

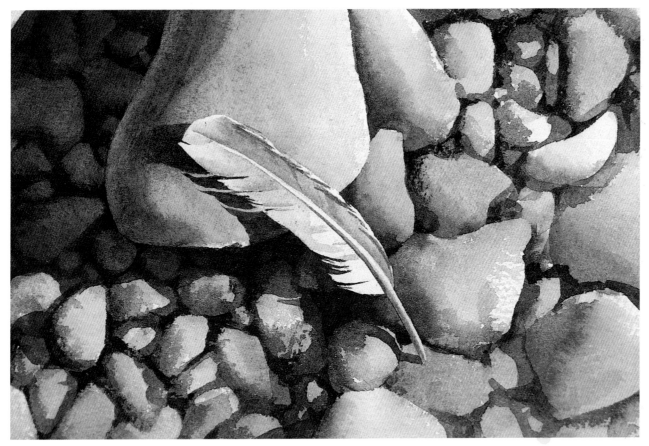

ROUNDED PEBBLES

The pebbles shown here form a pattern, and it's important not to make them look like eggs or jelly beans. Make a variety of shapes and sizes your goal for a study like this. First, I masked out the feather shape with liquid latex. Then I painted the sunlit side of the large stone with Burnt Sienna and Raw Sienna using a ¾-inch (2cm) aquarelle brush. I continued to shade the same rock as well as the cast shadows on it and next to it with the addition of Ultramarine Deep.

I worked each individual pebble in the same sunny colors used on the big stone, but I varied the dominance. The dark space between the rocks was painted with the same color as the shadows, but I blended their edges into the color of the pebbles with a no. 6 round Essex brush. To finish, I removed the masking and completed the feather with a gray mixed from Ultramarine Deep and Burnt Sienna.

WET-INTO-WET EXAMPLE

I began this detail by wetting the entire surface of the large rock with a 2-inch (5cm) soft slant brush. Next, I carefully painted the warm, sunny color with Burnt Sienna, Raw Sienna and a little Verzino Violet. Into this wet wash I charged the shadow colors, making sure that the edges blurred but stayed readable. This wash was dominated by Ultramarine Deep and included Burnt Sienna and a little Cupric Green Deep. While this wash was drying I finished the trees at the top. After everything was dry, I spattered a little texture over the nearest part of the rock with a toothbrush and drew the cracks with a no. 5 rigger.

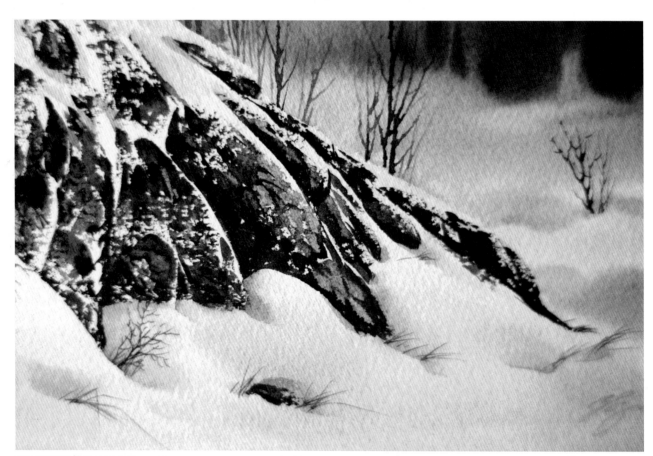

DRY-BRUSH EXAMPLE

I started with a light wash of Ultramarine Deep, Burnt Sienna and a little Green Blue all over the surface. After this dried, I drybrushed each section of the big rock with the curving side of a no. 6 round Essex brush filled with a very dark combination of Burnt Sienna, Ultramarine Deep and Permanent Violet Bluish. Controlling the dry brush was extremely important because all the white had to be protected as an essential part of the composition. After this was done, I painted the small twigs behind the rocks with a no. 3 rigger and the same colors used for the rocks.

Lace on the Rocks
11″ × 15″ (28cm × 38cm)

Step by Step: *Cuddlers*

Raw Sienna Burnt Sienna Permanent Violet Bluish Cobalt Blue Light Cupric Green Deep

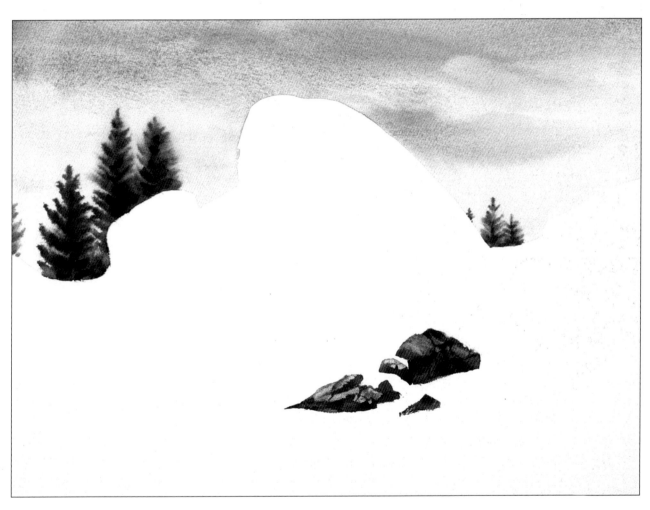

Step 1

On a dry surface, paint the sky shape right down to the edge of the future boulders with a very wet wash of Raw Sienna in a pale value. Into the wet wash, suggest the clouds with Cobalt Blue Light and Burnt Sienna using a 2-inch (5cm) soft slant brush. Into the still-moist color, paint the evergreens with rich paint in a 2-inch (5cm) slant bristle brush. Touch the surface of the paper with the edge of your brush separately for each branch. Switch to a ¾-inch (2cm) aquarelle brush and paint the silhouette of the foreground rocks with Cobalt Blue Light, Burnt Sienna and Permanent Violet Bluish in a thick consistency. With the heel of your palette knife, squeeze off the wet color and create the light modeling on the rocks.

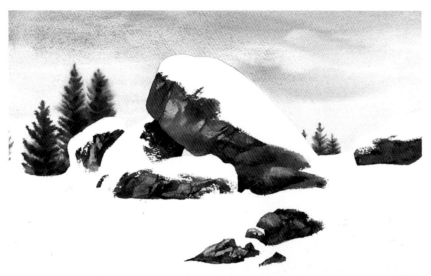

Step 2

Repeat the procedure for the larger rocks one at a time, making sure to lift off the damp color before each shape has a chance to dry. Protect the snow-covered area as you apply the color with the aquarelle brush.

Lost-and-Found Technique

When a brushstroke is hard on one side but blended away on the other, it is called a lost-and-found edge. To create this edge, use a 1-inch (2.5cm) slant bristle brush, thirsty moist, with its long-hair tip pointing to the edge you want to blend. Drag the brush parallel to the edge of the paint, actually touching the wet color. (Never drag the brush away from the paint or it will spread the color too far.) The thirsty brush moistens the paper next to the wet color and soaks up some of the color simultaneously, allowing the remaining paint to spread into the wide moist area and blend away to nothing.

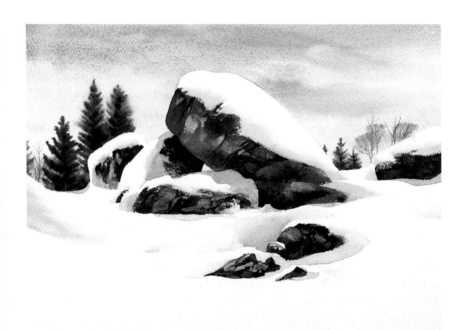

Step 3

After these shapes are dry, shade the snow around the rocks using Permanent Violet Bluish, Cupric Green Deep and a touch of Burnt Sienna. Apply the wash with the same aquarelle brush, using the lost-and-found technique (see sidebar). At the top edge of the snow-covered rock on the right side, add a few branches of deciduous trees with a no. 3 rigger. With the aquarelle brush add a light tone for the branches.

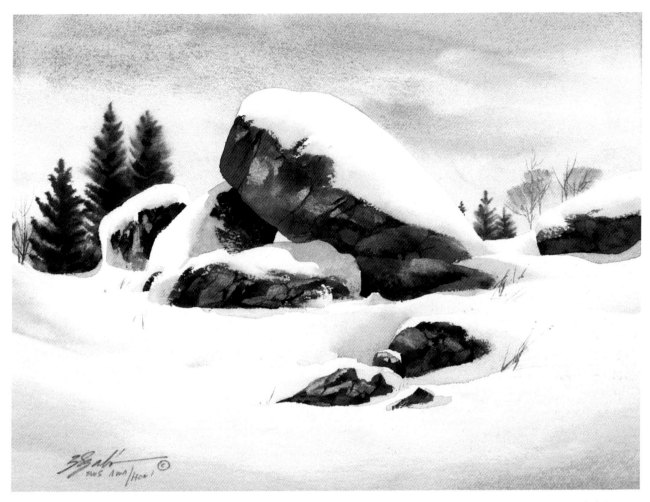

Step 4

To finish the painting, expand the shading on the snow similar to Step 3 for the smaller shapes. For the bottom edge, continue with the same colors but change to a 2-inch (5cm) soft slant brush in order to apply the color quickly.

Cuddlers
11″ × 15″ (28cm × 38cm)

Step by Step: *True Strength*

COLORS

Permanent
Yellow Deep

Burnt Sienna

Primary Red
Magenta

Green Blue

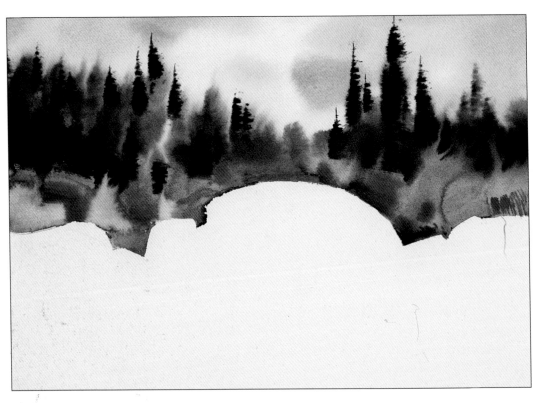

Step 1

Wet the top half of the paper to the edge of the
rocks. Using a 2-inch (5cm) soft slant brush,
apply the spots of blue sky with Green Blue and
the gray parts of the clouds with a mix of Burnt
Sienna, Primary Red Magenta and a touch of
Green Blue. Next switch to a 2-inch (5cm) slant
bristle brush and paint the evergreen trees by re-
peatedly touching the wet paper with the edge
of the brush loaded with Green Blue, Burnt Sienna
and some Permanent Yellow Deep. Charge the
bright shrubs below the trees using the same
brush but heavily relying on the three warm
colors only.

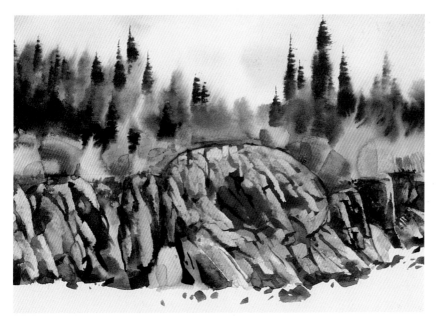

Step 2

Paint the rocky shapes in sections. Lay on the rich colors quickly with a ¾-inch (2cm) aquarelle brush. Before they dry, texture the shapes by pressing heavily on the heel of the palette knife. Drop in the two little yellow shrubs at the bottom edge of the rocks with the same aquarelle brush.

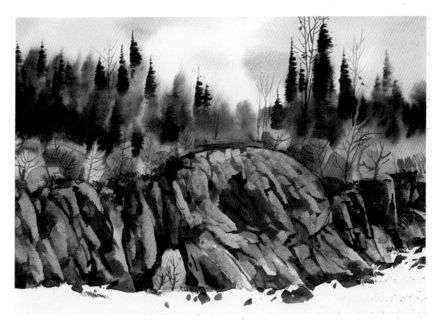

Step 3

When the surface is dry, add the darker and taller evergreens with Burnt Sienna and Green Blue in the slant bristle brush. Hold it sideways with the long end pointing downward. Glaze the overlapping sections of the small shrubs above the rocks.

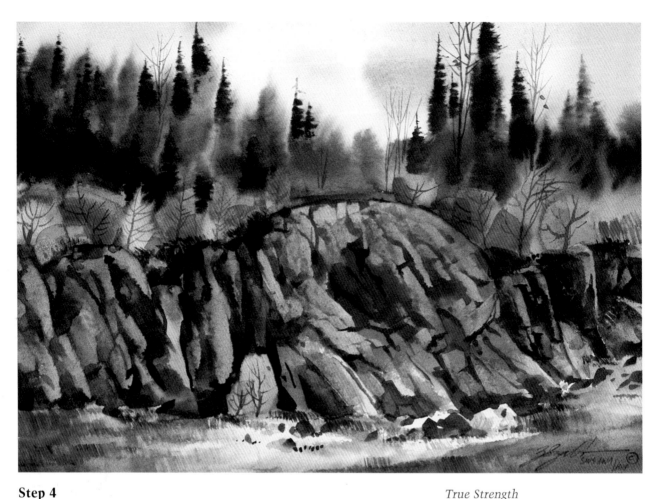

Step 4

Next add the calligraphic details to the shrubs and paint the few tall deciduous trees at the top with the point of a no. 3 rigger filled with a dark combination of all the colors in varied dominance. For the foreground, brush on the base colors using a 2-inch (5cm) slant bristle brush with combinations of all four colors with various dominance. Drybrush the occasional grass clusters simultaneously. Under the largest rock, paint a few dark jagged rocks to take advantage of the white sparkle and high contrast to emphasize the focal point.

True Strength
11″ × 15″ (28cm × 38cm)

Step by Step: *Spring Blanket*

Permanent
Violet Bluish

Orange Lake

Permanent
Green Yellowish

Cupric Green
Deep

Step 1

Using a 2-inch (5cm) soft slant brush on a very wet surface, paint the blue color with a combination of Cupric Green Deep and Permanent Violet Bluish. Create the pale yellow shapes with Permanent Green Yellowish and some Orange Lake. Darken the top corners by adding Permanent Violet Bluish to the previous two colors in darker value. As the colors begin to lose their shine, spatter some clean water onto the drying color and sprinkle in a few salt crystals to indicate some algae on the rocks. After the paint is dry, brush off the salt.

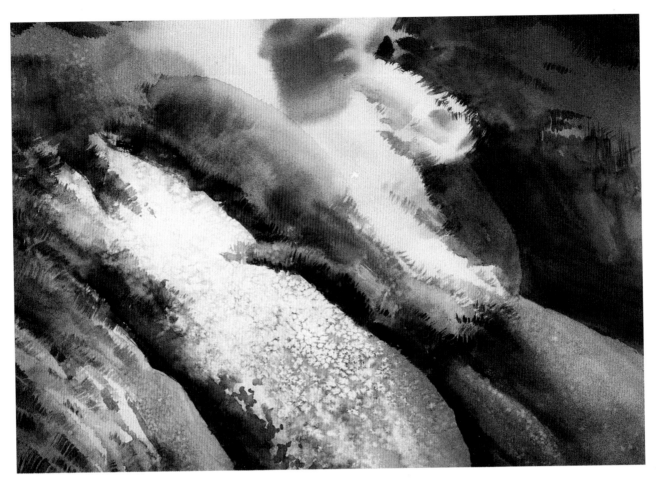

Step 2

Next introduce the darker shades by drybrushing darker tones of approximately the same colors in the same locations as in Step 1. The dry-brush technique naturally contributes to the textured nature of the subject. With a 2-inch (5cm) slant bristle brush, add further grassy clusters to the rich mossy growth using the same variety of related dark colors.

Drybrush

Drybrush is an effective technique to achieve coarse surface texture on rocks, and with a little green you can make it look like moss.

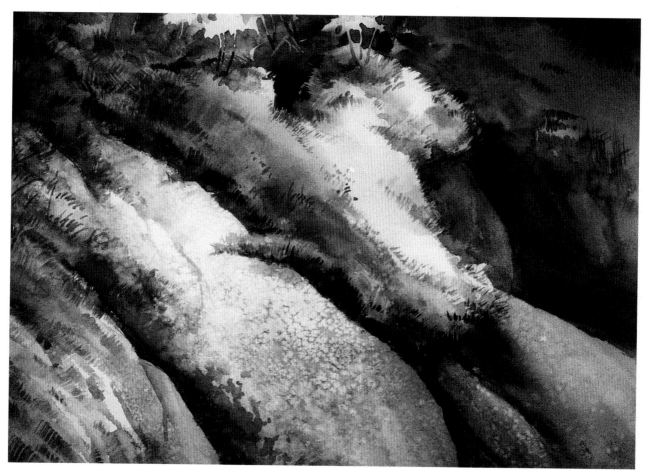

Step 3

Add more details to all the shapes, defining the
dark background at the top and the negative
young maple leaves creating a contrasting center
of interest.

Avoid Symmetry
When you repeat rock shapes, avoid symme-
try. Rounded rocks can easily look like turtles.

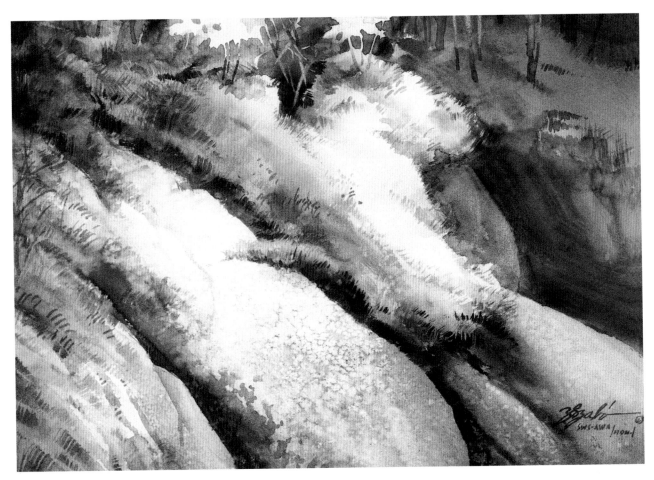

Step 4
Now add the darkest values and a few more details to finalize the illusion of depth on the completed painting.

Spring Blanket
11" × 15" (28cm × 38cm)

Step by Step: *Competitors*

Cobalt Blue Light

Permanent Violet Bluish

Permanent Yellow Deep

Cupric Green Deep

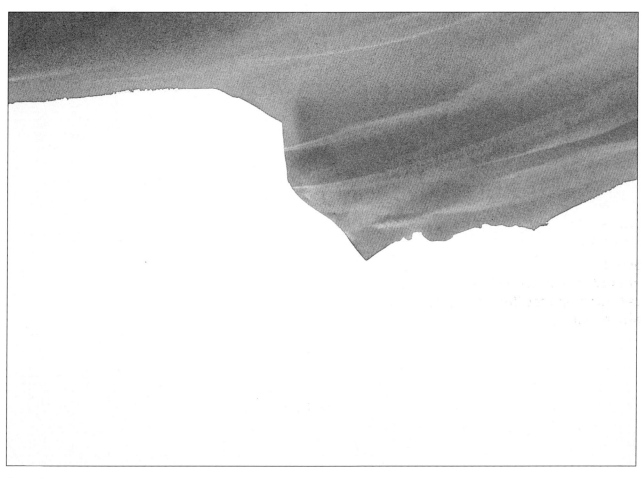

Step 1

Wet the sky area to exactly the top edge of the mountains. With a 1½-inch (4cm) soft slant brush, apply rich, angular brushstrokes of Cupric Green Deep and Permanent Violet Bluish, showing variation in color dominance. As the wash begins to lose its shine, lift out some light shapes with a clean, thirsty brush squeezed dry of excess moisture.

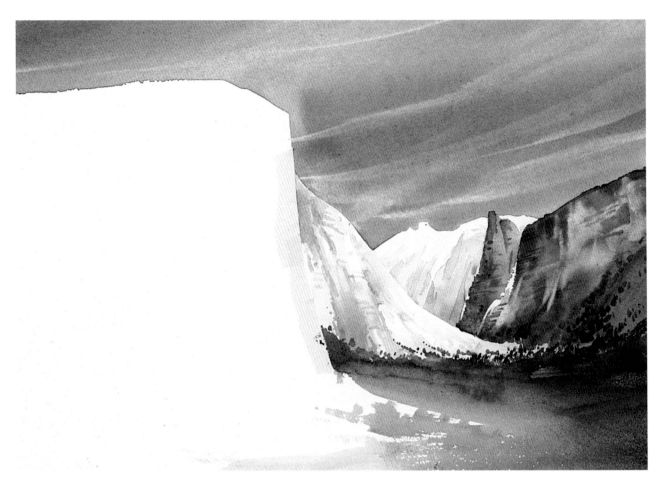

Step 2

Mask the right edge of the foreground mountain first. Paint the base washes over the distant mountains with a ¾-inch (2cm) aquarelle brush using Cobalt Blue Light, Permanent Violet Bluish and a little Permanent Yellow Deep. Continue by glazing more texture and depth to the mountainsides with the same brush and colors. Start the distant forest in the valley. On the right side add a lot of Cupric Green Deep and Permanent Violet Bluish to the mix.

Steps 3 and 4
With a 2-inch (5cm) slant bristle brush, paint the warm neutral base under the forest of the left slope. Into this quickly drying color, paint the rows of trees using the same brush filled with a rich combination of all the colors except Cobalt Blue Light.

Glaze the details of the largest white cliff last. To do this, use a 1½-inch (4cm) soft slant brush to apply light washes over and over until the value, color and texture are just right. Add a few tiny trees to the top edge of the cliff and refine a few more dotted trees at the bottom of the rocks.

Competitors
11″ × 15″ (28cm × 38cm)

Earth Colors
Earth colors seem to have a natural color relationship with rocks. Alone or mixed they work, but use them thinned with water.

Step by Step: *Sunbathers*

Permanent Yellow Deep
Burnt Sienna
Verzino Violet
Cobalt Blue Light
Cupric Green Deep

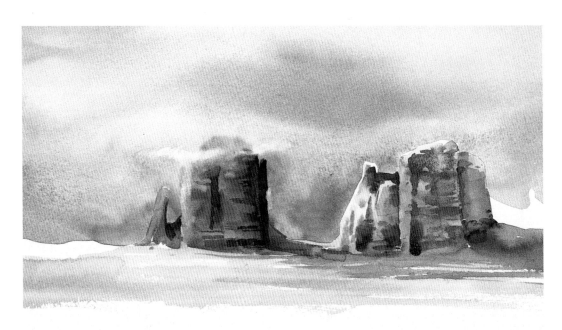

Step 1

Wet the sky area only. Paint the clouds with a 2-inch (5cm) soft slant brush filled with Cobalt Blue Light and Burnt Sienna in varying strength and dominance. As the color starts to lose its shine, wipe off the light cloud to be in front of the smaller butte. Paint the warm colors of the buttes and the rocks under them. Use a ¾-inch (2cm) aquarelle brush and vary Verzino Violet, Permanent Yellow Deep and Burnt Sienna with warm color dominant. Add a little Cobalt Blue Light to cool the shaded sides.

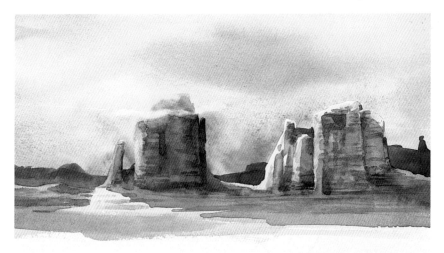

Step 2

Glaze the cast shadows onto the buttes with Cobalt Blue Light and a little Burnt Sienna in the soft slant brush. Keep the edges sharp next to the sunlit edges, but paint the complete shadow as one connected, well-blended tone. Switch to the ¾-inch (2cm) aquarelle brush and apply the darker shapes of the shaded distant hills behind the brightly sunlit middle ground using Cupric Green Deep, Cobalt Blue Light and Verzino Violet.

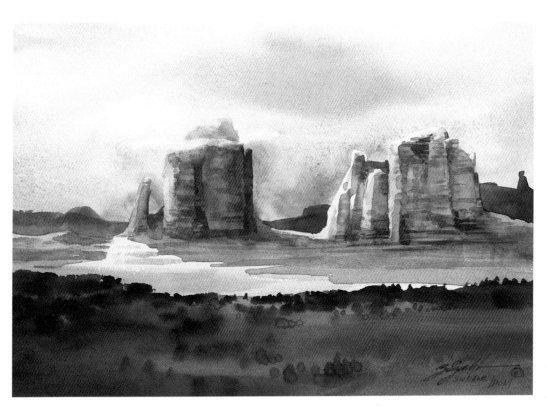

Sunbathers
11" × 15" (28cm × 38cm)

Step 3

Changing back to the same soft slant brush, apply a rich wash for the foreground mixed from Burnt Sienna, Verzino Violet and a little Cupric Green Deep. Into this wet wash add the dark trees mainly to the upper edge and some to the interior of the foreground. Blend the shapes more in the interior and keep a sharp contrast next to the sunlight to keep the viewer's interest inside the painting.

Rocks Next to Water

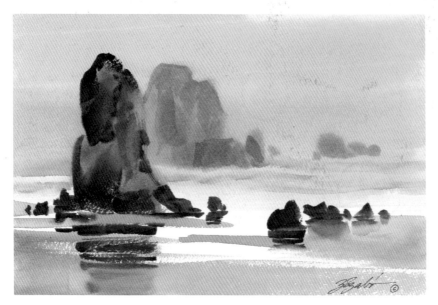

NEAR AND DISTANT ROCKS

The west coast of North America is sprinkled with spectacular rocks. I used a ¾-inch (2cm) aquarelle brush for this entire piece. I started by painting the sky with a wash of Raw Sienna, Ultramarine Deep and some Burnt Sienna. About two-thirds down I blended the edge into the white paper. While the paper was still wet, I dropped in the middle-ground pale rocks with the same colors in a slightly darker value.

The darkest rocks up front came next. I used Ultramarine Deep, Burnt Sienna and Permanent Violet Bluish in varied dominance for the rocks and their reflection. I used the same colors for the sandy foreground as I used for the sky, but carefully painted around the white reflections using rapid, horizontal brushstrokes. The sparkling edges were created with dry-brush touches.

ROCKS FROM A DISTANCE

For this quick study from the coast of Oregon, I used a ¾-inch (2cm) aquarelle brush with five colors. The gray sky is a light wash mixed from Cobalt Blue Light and Burnt Sienna. (I charged in a drop of Cupric Green Deep in spots.) After drying I glazed the distant mountain with Cobalt Blue Light and Burnt Sienna. When this wash was dry, I superimposed the big, dark rocks using Burnt Sienna, Cobalt Blue Light and a little Permanent Violet Bluish. The water is a combination wash of Cobalt Blue Light, Cupric Green Deep and Burnt Sienna. The sandy beach is Raw Sienna, Burnt Sienna and Cobalt Blue Light. While this wash was still wet I wet-lifted out the white foam with a thirsty brush.

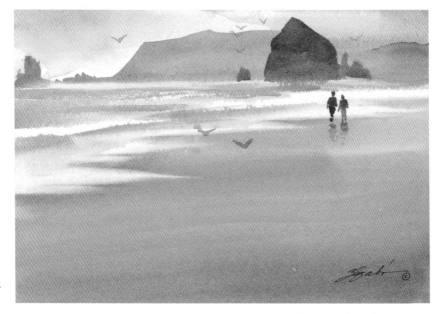

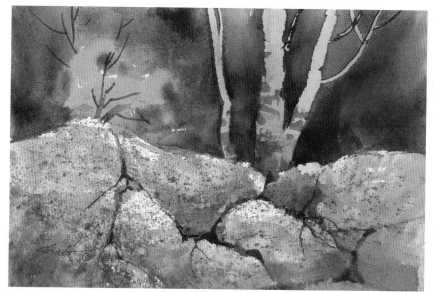

First I spattered texture over the rocky section with a toothbrush using Ivory Black and Green Blue. Next I applied a casually placed pale glaze with varied color dominance using Primary Red Magenta, Green Blue and Ivory Black. In the background I used a dark mix of Ivory Black, Raw Sienna, Primary Red Magenta and some Green Blue. While this wash was wet, I scraped off the birch tree trunks with the slanted tip of an aquarelle brush handle. I finished the reddish spots on the trees with Raw Sienna and Primary Red Magenta.

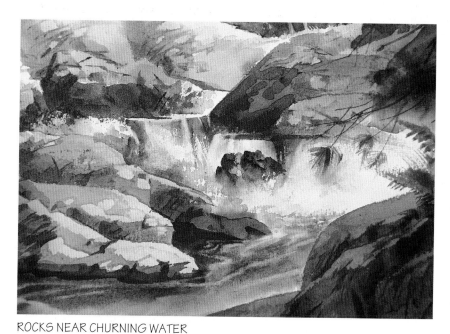

ROCKS NEAR CHURNING WATER

This complex-looking detail was really a simple technical challenge. I painted the silhouette of each rock with a combination wash of Raw Sienna, Burnt Sienna, Verzino Violet and Ultramarine Deep in differing dominance with a 1-inch (2.5cm) aquarelle brush. I scraped off the light textures with my palette knife while the base wash was still damp. For the churning water I used Cupric Green Deep, Ultramarine Deep and some Burnt Sienna mixed into one wash. My colors for the dark rocks were mixed from Ultramarine Deep, Verzino Violet and Cupric Green Deep.

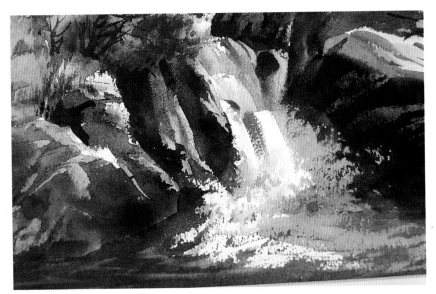

DARKER ROCKS BY CHURNING WATER

My procedure for this detail was similar to that of the detail on page 115. I painted each rock separately. The light part is Burnt Sienna and a touch of Cadmium Yellow Lemon; the dark shaded part, Cupric Green Deep, Verzino Violet and Permanent Violet Bluish. While the shape was wet, I scraped off the lighter values with my palette knife. I repeated this procedure for each rock. The gushing water was created with a wash of Cupric Green Deep and Permanent Violet Bluish.

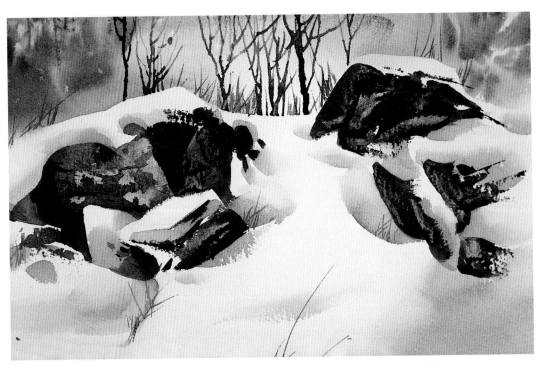

SNOW-COVERED ROCKS

In this winter landscape detail, the rocks are isolated dark shapes, while the snow around them is a connected light unit. I started by painting each rock separately with a 1-inch (2.5cm) aquarelle brush filled with a rich mix of Burnt Sienna, Raw Sienna and Ultramarine Deep. I scraped off the angular lighter texture from the wet color with my palette knife.

After the rocks dried, I painted the soft shading of the snow next to them. For this modeled wash, I used a 1½-inch (4cm) soft slant brush to apply the color, and a thirsty 1-inch (2.5cm) slant bristle brush to blend away the softer edges. I added a gentle touch of Raw Sienna to the sky at the top and a few trees for scale. Burnt Sienna and Ultramarine Deep supplied the grayish tones.

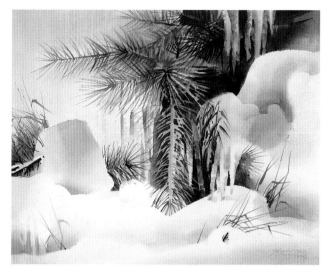

ICY ROCKS

The rocks are covered with ice on this close-up detail. The ice formations are round and require a soft blending technique. I used a 1-inch (2.5cm) aquarelle brush to apply the blue washes made from Cobalt Blue Light, Cupric Green Deep and a touch of Verzino Violet. To blend the washes, I used a 1-inch (2.5cm) slant bristle brush in a thirsty but damp condition. I treated the icicles as negative shapes by painting around them. For the darker area near the pine needles, I added Raw Sienna and Permanent Violet Bluish to complete my palette. You can see the color dominance on each shape.

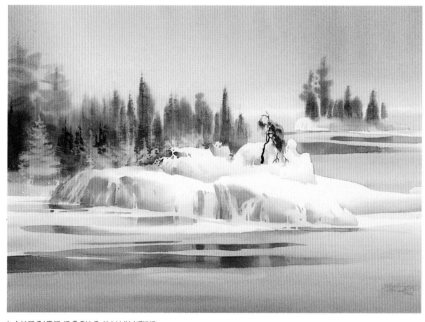

The Aftermath
15″ × 20″ (38cm × 51cm)

LAKESIDE ROCKS IN WINTER

Rocks at the edge of large lakes disappear under a coating of ice after a rough winter storm. Here I started with the pale gray sky and middle-ground and foreground snow using a mix of Burnt Sienna and Ultramarine Deep in a 2-inch (5cm) soft slant brush. I left lots of white for the icy rocks. While the sky was still damp, I painted the dark evergreens with a 2-inch (5cm) slant bristle brush full of a thick mixture of Burnt Sienna, Cupric Green Deep and Ultramarine Deep.

After everything dried, I painted the dripping ice on the invisible rocks with several small glazes of Cupric Green Deep, Ultramarine Deep and some Burnt Sienna, applied with a no. 5 round Essex brush. For the horizontal, dark reflecting puddles in the foreground, I used a medium-dark brushstroke to define the shapes and charged them with extremely dark and thick color to indicate the blurring reflections of the distant trees.

Layered Blue Slate Rocks

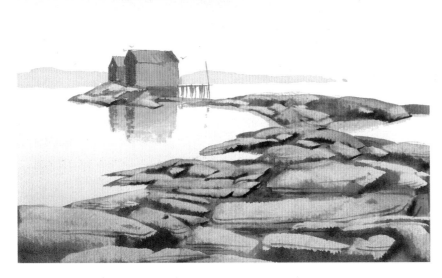

TWO-COLOR STUDY
Using just two colors, Raw Sienna and Ultramarine Deep, made it easy to control the tonal value here. I began with a graded wash, shaded at the top and bottom and light near the horizon, using my 1½-inch (4cm) soft slant brush. After this wash dried, I painted the rocks with a ¾-inch (2cm) aquarelle brush using both colors in a medium-dark value. Your paint should be thick, the consistency of cream. I immediately scraped off the light shapes with the heel of my palette knife. I repeated this procedure several times making sure the paint stayed moist for the knife treatment.

To finish, on a dry surface, I drew in the darker lines that indicate the layers of dry-looking slate rocks. I also placed the buildings and the pale distant point to boost the illusion of depth.

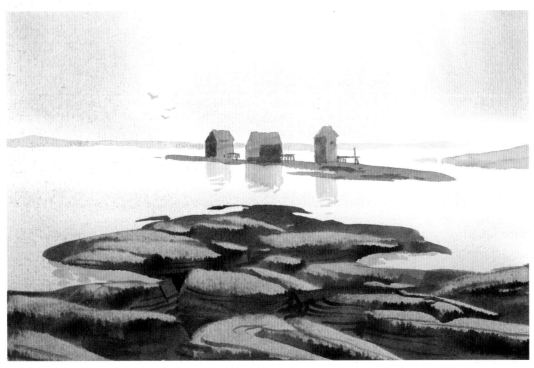

GREATER VALUE CONTRAST
The value contrast is considerably greater on this study. This time I used Raw Sienna and Ultramarine Deep with the addition of Burnt Sienna for stronger darks. First, I wet the paper. In the middle of the sky I washed in a little Raw Sienna and a light gray tone of Raw Sienna and Ultramarine Deep with my 1½-inch (4cm) soft slant brush. The treatment for the rocks was the same as in the previous study, but this time I used Ultramarine Deep with Burnt Sienna to gain a deeper dark. The scrape marks of the palette knife allow the same blue color to prevail as in the original dark wash. The result is a greater contrast and a wet look.

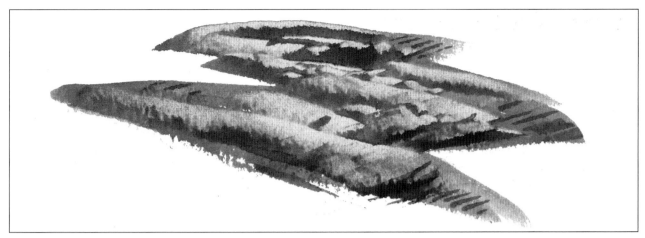

WORKABLY WET
This small detail of flat rocks shows the size of a shape that is reasonably easy to keep wet for knife work. The sketch also shows scrape marks applied just at the right time.

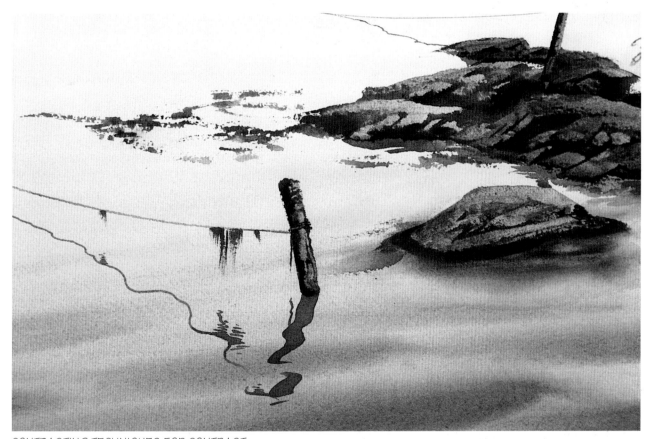

CONTRASTING TECHNIQUES FOR CONTRAST
This detail shows the same kind of flat rocks contrasting against the smooth wet-into-wet technique of the water. The colors for the water are Ultramarine Deep and Cupric Green Deep. After the background dried, I added Burnt Sienna and Permanent Violet Bluish for the rocks. The procedure for the texture of the rocks was the same as in the previous studies.

Porous or Sedimentary Rocks

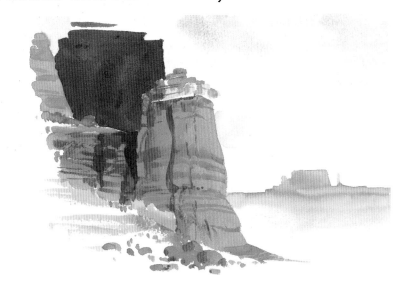

DESERT BUTTES

Buttes in the desert are sedimentary rocks. The layers of ancient sediments are clearly visible in varied color. Many of these rocks are red, and the veins show in a darker or lighter value. This is a simple rendering of one of these sculptured formations of nature. On the sunny rocks I used Burnt Sienna and Primary Red Magenta. I added a little Ultramarine Deep to the shaded areas.

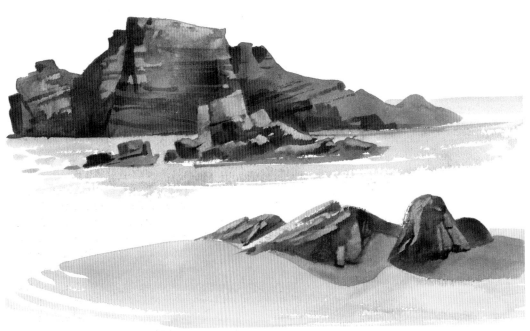

STRONG SEDIMENTARY PATTERNS

Here I wanted to emphasize the strong patterns caused by the sedimentary layers, so I pressed my palette knife horizontally to scrape off light shapes from wet paint. After the base wash dried, I deposited the thin dark lines with wet paint on the edge of my palette knife. On the top rock formation I used Burnt Sienna, Verzino Violet and Ultramarine Deep. For the smaller rock formation on the bottom, I chose Raw Sienna, Ultramarine Deep and Permanent Violet Bluish. The palette knife worked effectively in both cases.

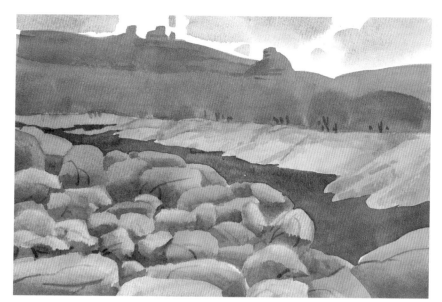

ROCKS UPON ROCKS
The background is not finished in this quick study. I used a ¾-inch (2cm) aquarelle brush and painted the piled rocks with Raw Sienna and Ultramarine Deep only. I did the base wash in small sections so I could scrape off the light tops of the rock shapes while the color was still wet. As the knife deposited the accumulated colors at the base of each shape, the color naturally became darker. After drying I hinted at a few dark cracks with a small rigger.

SEDIMENTARY COLORS FOR DESERT ROCKS
Two sedimentary colors worked well to show these desert rocks. Using my ¾-inch (2cm) aquarelle brush for the base wash, I painted the shapes with Raw Sienna and Ultramarine Deep; Raw Sienna dominated the mix. For the darker modeling I let the blue dominate. The coarse texture is the result of the interaction between the sedimentary colors.

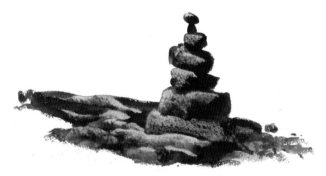

LAVA ROCKS
The native Hawaiians build little lava rock monuments to honor Pele, the unpredictable goddess of volcanoes. They look something like this. Lava rocks are difficult to paint because they are usually black with only subtle hints of color. For this study I used Ivory Black mixed with Burnt Sienna for the lower rocks, and Ivory Black with Ultramarine Deep for the pile. Only the black showed as I applied the dark color until I scraped off the texture with the heel of my palette knife. The warm and cool color influences are detectable where the black has been weakened sufficiently.

Use Sedimentary Colors
Use sedimentary colors whenever possible as a general rule for painting porous rocks. Many of the sedimentary colors are earth colors to begin with, so they're in a conveniently correct color range. Burnt Sienna, Raw Sienna, Burnt Umber, Raw Umber, Ultramarine Deep and Ivory Black are a few sedimentary colors. The grainy appearance of porous rocks naturally relates to the sandy-looking texture of sedimentary washes.

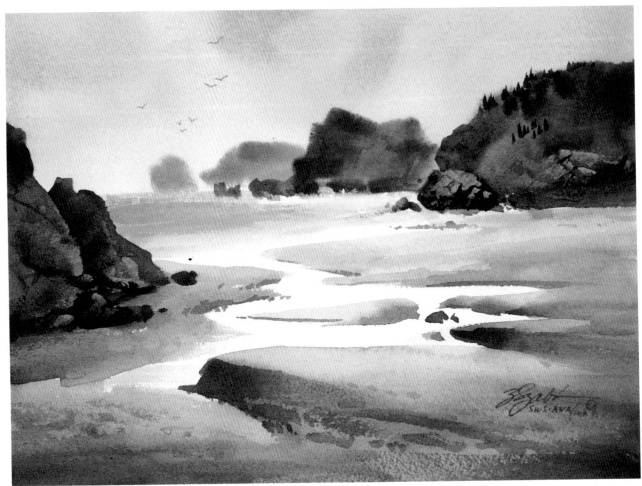

LAVA ROCK FORMATIONS

Geologically young lava rock formations are the subject of this coastal land-scape. I started with light washes of all four colors—Raw Sienna, Cupric Green Deep, Primary Red Magenta and Permanent Violet Bluish—in a light value and in varied dominance on wet paper for the sky and sand. After the surface lost its shine but still felt moist, I used a 1½-inch (4cm) soft slant brush. Then I re-duced the amount of water and increased the strength of the pigment in my brush to paint the sand islands and the distant water. I used Raw Sienna, Cupric Green Deep and Permanent Violet Bluish, varying the color dominance from shape to shape.

Next I used a 1½-inch (4cm) slant bristle brush to paint the rock clusters, starting from the lightest and coolest ones at the back and getting darker and warmer as I moved forward. The nearest rocks have all four colors in them while the distant ones are mixed from only Cupric Green Deep and Permanent Violet Bluish. I used a little palette-knife work on the closer and darker shapes.

Tide Turtles
15″ × 20″ (38cm × 51cm)

Step by Step: *Floating Castle*

Cadmium
Yellow Lemon

Verzino Violet

Permanent
Violet Bluish

Cobalt Blue
Light

Cupric Green
Deep

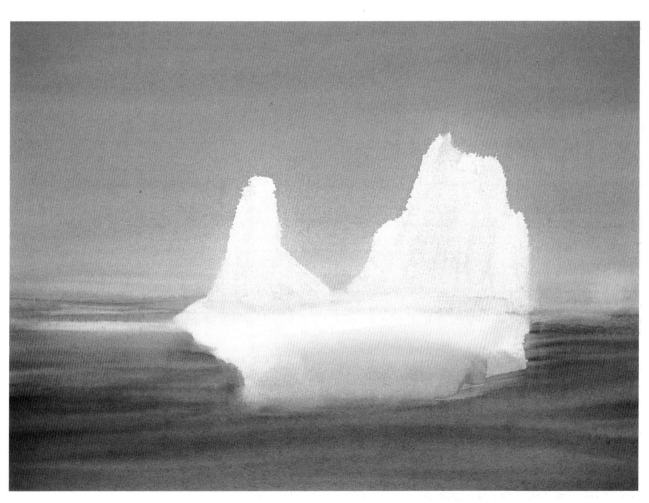

Step 1

Start on wet paper with Cadmium Yellow Lemon and Verzino Violet for the horizon. Use a 2-inch (5cm) soft slant brush and spread the orange color up into the sky as well as down into the reflecting water. Simultaneously paint the dark northern sky starting at the top with the same brush, using Cupric Green Deep, Permanent Violet Blu-ish and adding Verzino Violet near the horizon to blend with the warm colors. Use a similar approach for the dark sky reflections in the foreground. While the entire paper is still quite damp, wipe off the shape of the iceberg and its reflection and recover most of the light paper.

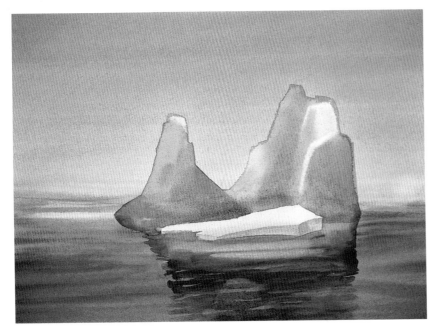

Step 2
Use a ¾-inch (2cm) aquarelle brush to paint the base washes for the iceberg using mostly Cupric Green Deep, but adding Permanent Violet Bluish and some Cobalt Blue Light. Next paint the deep reflection with the same colors in a much darker value.

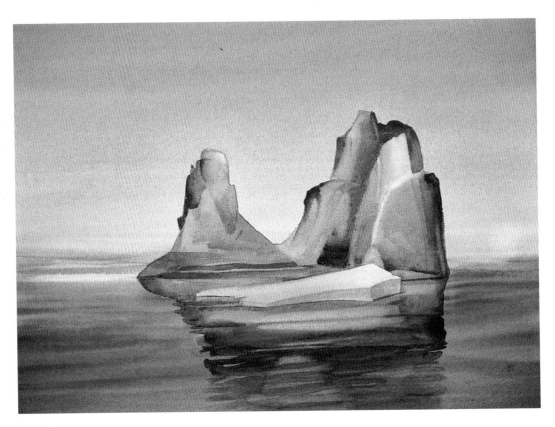

Step 3
Continue to create definition on the iceberg as well as on the reflection. Lift out more light shapes from the right side of the largest part of the iceberg and lighten the reflection of the sky between the two points.

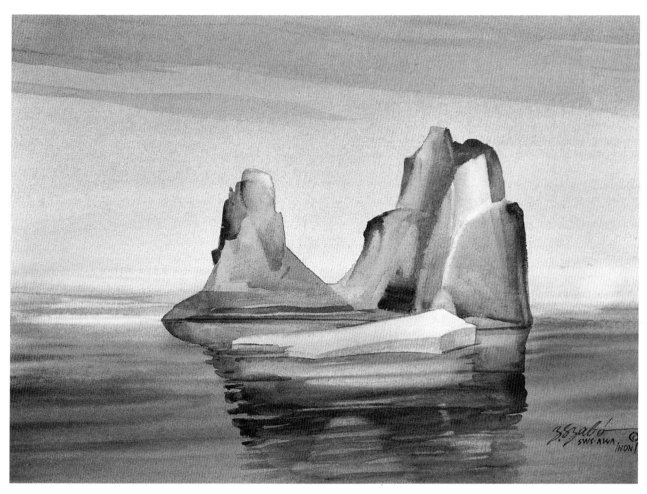

Step 4

Make a few adjustments as necessary to show medium light in the reflection. Then mix a neutral wash of Permanent Violet Bluish, Cupric Green Deep and just a touch of Cadmium Yellow Lemon. Using a 1½-inch (4cm) soft slant brush, paint with the neutral wash a few gently glazed shapes to the top of the sky, indicating clouds.

Floating Castle
11″×15″ (28cm×38cm)

INDEX